MORNINGS
IN FLORENCE

BY

JOHN RUSKIN

Author of "Sesame and Lilies," "The True and Beautiful," "The
Crown of Wild Olive," "The Queen of the Air," "The
King of the Golden River," Etc.

CHICAGO
HOMEWOOD PUBLISHING COMPANY

Republished 1977
SCHOLARLY PRESS, INC.
19722 E. Nine Mile Rd., St. Clair Shores, Michigan 48080

Library of Congress Catalog Card Number: 71-115266
ISBN 0-403-00306-7

CONTENTS.

3

PREFACE.

It seems to me that the real duty involved in my Oxford professorship cannot be completely done by giving lectures in Oxford only, but that I ought also to give what guidance I may to travelers in Italy.

The following letters are written as I would write to any of my friends who asked me what they ought preferably to study in limited time; and I hope they may be found of use if read in the places which they describe, or before the pictures to which they refer. But in the outset let me give my readers one piece of practical advice. If you can afford it, pay your custode or sacristan well. You may think it an injustice to the next comer; but your paying him ill is an injustice to all comers, for the necessary result of your doing so is that he will lock up or cover whatever he can, that he may get his penny fee for showing it; and that, thus exacting a small tax from everybody, he is thankful to none, and gets into a sullen passion if you stay more than a quarter of a min-

ute to look at the object after it is uncovered.
And you will not find it possible to examine
anything properly under these circumstances.
Pay your sacristan well, and make friends with
him: in nine cases out of ten an Italian is really
grateful for the money, and more than grateful
for human courtesy; and will give you some true
zeal and kindly feeling in return for a franc
and a pleasant look. How very horrid of him
to be grateful for money, you think! Well, I
can only tell you that I know fifty people who
will write me letters full of tender sentiment,
for one who will give me tenpence; and I shall
be very much obliged to you if you will give
me tenpence for each of these letters of mine,
though I have done more work than you know
of, to make them good ten-penny worths to you.

MORNINGS IN FLORENCE.

THE FIRST MORNING.

SANTA CROCE.

If there is one artist, more than another, whose work it is desirable that you should examine in Florence, supposing that you care for old art at all, it is Giotto. You can, indeed, also see work of his at Assisi; but it is not likely you will stop there, to any purpose. At Padua there is much; but only of one period. At Florence, which is his birthplace, you can see pictures by him of every date and every kind. But you had surely better see, first, what is of his best time and of the best kind. He painted very small pictures and very large —painted from the age of twelve to sixty— painted some subjects carelessly which he had little interest in—some carefully with all his heart. You would surely like, and it would certainly be wise, to see him first in his strong and earnest work,—to see a painting by him, if possible, of large size, and wrought with his

full strength, and of a subject pleasing to him. And if it were, also, a subject interesting to yourself,—better still.

Now, if indeed you are interested in old art, you cannot but know the power of the thirteenth century. You know that the character of it was concentrated in, and to the full expressed by, its best king, St. Louis. You know St. Louis was a Franciscan, and that the Franciscans, for whom Giotto was continually painting under Dante's advice, were prouder of him than of any other of their royal brethren or sisters. If Giotto ever would imagine anybody with care and delight, it would be St. Louis, if it chanced that anywhere he had St. Louis to paint.

Also, you know that he was appointed to build the Campanile of the Duomo, because he was then the best master of sculpture, painting, and architecture in Florence, and supposed to be without superior in the world. And that this commission was given him late in life (of course he could not have designed the Campanile when he was a boy), so therefore, if you find any of his figures painted under pure campanile architecture, and the architecture by his hand, you know, without other evidence, that the painting must be of his strongest time.

So if one wanted to find anything of his to begin with, especially, and could choose what it should be, one would say, "A fresco, life size, with campanile architecture behind it, painted in an important place; and if one might choose one's subject, perhaps the most interesting saint of all saints—for him to do for us—would be St. Louis."

Wait then for an entirely bright morning; rise with the sun, and go to Santa Croce, with a good opera-glass in your pocket, with which you shall for once, at any rate, see an opus; and, if you have time, several opera. Walk straight to the chapel on the right of the choir ("k" in your Murray's Guide). When you first get into it, you will see nothing but a modern window of glaring glass, with a red-hot cardinal in one pane—which piece of modern manufacture takes away at least seven-eights of the light (little enough before) by which you might have seen what is worth sight. Wait patiently till you get used to the gloom. Then, guarding your eyes from the accursed modern window as best you may, take your opera-glass and look to the right, at the uppermost of the two figures beside it. It is St. Louis, under campanile architecture, painted by—Giotto? or the last Florentine painter who wanted a job—

over Giotto? That is the first question you
have to determine; as you will have hencefor-
ward, in every case in which you look at a
fresco.

Sometimes there will be no question at all.
These two gray frescos at the bottom of the
walls on the right and left, for instance, have
been entirely got up for your better satisfaction,
in the last year or two—over Giotto's half-
effaced lines. But that St. Louis? Repainted
or not, it is a lovely thing,—there can be no
question about that; and we must look at it,
after some preliminary knowledge gained, not
inattentively.

Your Murray's Guide tells you that this
chapel of the Bardi della Liberta, in which you
stand, is covered with frescos by Giotto; that
they were whitewashed, and only laid bare in
1853; that they were painted between 1296 and
1304; that they represent scenes in the life of
St. Francis; and that on each side of the win-
dow are paintings of St. Louis of Toulouse, St.
Louis, king of France, St. Elizabeth, of Hun-
gary, and St. Claire,—"all much restored and
repainted." Under such recommendation, the
frescos are not likely to be much sought after;
and accordingly, as I was at work in the chapel
this morning, Sunday, 6th September, 1874,

two nice-looking Englishmen, under guard of their *valet de place*, passed the chapel without so much as looking in.

You will perhaps stay a little longer in it with me, good reader, and find out gradually where you are. Namely, in the most interesting and perfect little Gothic chapel in all Italy —so far as I know or can hear. There is no other of the great time which has all its frescos in their place. The Arena, though far larger, is of earlier date—not pure Gothic, nor showing Giotto's full force. The lower chapel at Assisi is not Gothic at all, and is still only of Giotto's middle time. You have here, developed Gothic, with Giotto in his consummate strength, and nothing lost, in form, of the complete design.

By restoration—judicious restoration, as Mr. Murray usually calls it—there is no saying how much you have lost. Putting the question of restoration out of your mind, however, for a while, think where you are, and what you have got to look at.

You are in the chapel next the high altar of the great Franciscan church of Florence. A few hundred yards west of you, within ten minutes' walk, is the Baptistery of Florence. And five minutes' walk west of that is the great

Dominican church of Florence, Santa Maria Novella.

Get this little bit of geography and architectural fact well into your mind. There is the little octagon Baptistery in the middle; here, ten minutes, walk east of it, the Franciscan church of the Holy Cross; there, five minutes' walk west of it, the Dominican church of St. Mary.

Now, that little octagon Baptistery stood where it now stands (and was finished, though the roof has been altered since) in the eighth century. It is the central building of Etrurian Christianity,—of European Christianity.

From the day it was finished, Christianity went on doing her best, in Etruria and elsewhere, for four hundred years,—and her best seemed to have come to very little,—when there rose up two men who vowed to God it should come to more. And they made it come to more, forthwith; of which the immediate sign in Florence was that she resolved to have a fine new cross-shaped cathedral instead of her quaint old little octagon one; and a tower beside it that should beat Babel:—which two buildings you have also within sight.

But your business is not at present with them, but with these two earlier churches of Holy

Cross and St. Mary. The two men who were the effectual builders of these were the two great religious Powers and Reformers of the thirteenth century;—St. Francis, who taught Christian men how they should behave, and St. Dominic, who taught Christian men what they should think. In brief, one the Apostle of Works; the other of Faith. Each sent his little company of disciples to teach and to preach in Florence: St. Francis in 1212; St. Dominic in 1220.

The little companies were settled—one, ten minutes' walk east of the old Baptistery; the other, five minutes' walk west of it. And after they had stayed quietly in such lodgings as were given them, preaching and teaching through most of the century, and had got Florence, as it were, heated through, she burst out into Christian poetry and architecture, of which you have heard much talk:—burst into bloom of Arnolfo, Giotto, Dante, Orcagna, and the like persons, whose works you profess to have come to Florence that you may see and understand.

Florence then, thus heated through, first helped her teachers to build finer churches. The Dominicans, or White Friars, the Teachers of Faith, began their church of St. Mary's in

1279. The Franciscans, or Black Friars, the teachers of Works, laid the first stone of this church of the Holy Cross in 1294. And the whole city laid the foundations of its new cathedral in 1298. The Dominicans designed their own building; but for the Franciscans and the town worked the first great master of Gothic art, Arnolfo; with Giotto at his side, and Dante looking on, and whispering sometimes a word to both.

And here you stand beside the high altar of the Franciscans' church, under a vault of Arnolfo's building, with at least some of Giotto's color on it still fresh; and in front of you, over the little altar, is the only reportedly authentic portrait of St. Francis, taken from life by Giotto's master. Yet I can hardly blame my two English friends for never looking in. Except in the early morning light, not one touch of all this art can be seen. And in any light, unless you understand the relations of Giotto to St. Francis, and of St. Francis to humanity, it will be of little interest.

Observe, then, the special character of Giotto among the great painters of Italy is his being a practical person. Whatever other men dreamed of, he did. He could work in mosaic; he could work in marble; he could paint; and

he could build: and all thoroughly: a man of supreme faculty, supreme common sense. Accordingly, he ranges himself at once among the disciples of the Apostle of Works, and spends most of his time in the same apostleship.

Now the gospel of Works, according to St. Francis, lay in three things. You must work without money, and be poor. You must work without pleasure, and be chaste. You must work according to orders, and be obedient.

Those are St. Francis' three articles of Italian opera. By which grew the many pretty things you have come to see here.

And now if you will take your opera-glass and look up to the roof above Arnolfo's building, you will see it is a pretty Gothic cross vault, in four quarters, each with a circular medallion, painted by Giotto. That over the altar has the picture of St. Francis himself. The three others, of his Commanding Angels. In front of him over the entrance arch, Poverty. On his right hand, Obedience. On his left, Chastity.

Poverty, in a red patched dress, with gray wings, and a square nimbus of glory above her head, is flying from a black hound, whose head is seen at the corner of the medallion.

Chastity, veiled, is imprisoned in a tower, while angels watch her.

Obedience bears a yoke on her shoulders, and lays her hand on a book.

Now, this same quatrefoil, of St. Francis and his three Commanding Angels, was also painted, but much more elaborately, by Giotto, on the cross vault of the lower church of Assisi, and it is a question of interest which of the two roofs was painted first.

Your Murray's Guide tells you the frescos in this chapel were painted between 1296 and 1304. But as they represent, among other personages St. Louis of Toulouse who was not canonized till 1317, that statement is not altogether tenable. Also, as the first stone of the church was only laid in 1294, when Giotto was a youth of eighteen, it is little likely that either it would have been ready to be painted, or he ready with his scheme of practical divinity, two years later.

Farther, Arnolfo, the builder of the main body of the church, died in 1310. And as St. Louis of Toulouse was not a saint till seven years afterward, and the frescos therefore beside the window not painted in Arnolfo's day, it becomes another question whether

Arnolfo left the chapels, or the church at all, in their present form.

On which point—now that I have shown you where Giotto's St. Louis is—I will ask you to think awhile, until you are interested: and then I will try to satisfy your curiosity. Therefore, please leave the little chapel for the moment, and walk down the nave, till you come to two sepulchral slabs near the west end, and then look about you and see what sort of a church Santa Croce is.

Without looking about you at all, you may find, in your Murray, the useful information that it is a church which "consists of a very wide nave and lateral aisles, separated by seven fine pointed arches." And as you will be—under ordinary conditions of tourist hurry —glad to learn so much, without looking, it is little likely to occur to you that this nave and two rich aisles required also, for your complete present comfort, walls at both ends, and a roof on the top. It is just possible, indeed, you may have been struck, on entering, by the curious disposition of painted glass at the east end;—more remotely possible that, in returning down the nave, you may this moment have noticed the extremely small circular window at the west end; but the chances are a thou-

2

sand to one that, after being pulled from tomb
to tomb round the aisles and chapels, you
should take so extraordinary an additional
amount of pains as to look up at the roof, —
unless you do it now quietly. It will have had
its effect upon you, even if you don't, without
your knowledge. You will return home with
a general impression that Santa Croce is, some-
how, the ugliest Gothic church you ever were
in. Well, that is really so; and now, will you
take the pains to see why?

There are two features, on which, more than
on any others, the. grace and delight of a fine
Gothic building depends; one is the springing
of its vaultings, the other the proportion and
fantasy of its traceries. This church of Santa
Croce has no vaultings at all, but the roof of a
farm-house barn. And its windows are all of
the same pattern, —the exceedingly prosaic one
of two pointed arches, with a round hole above,
between them.

And to make the simplicity of the roof more
conspicuous, the aisles are successive sheds built
at every arch. In the aisles of the Campo Santo
of Pisco, the unbroken flat roof leaves the eye
free to look to the traceries; but here, a suc-
cession of up-and-down sloping beam and lath
gives the impression of a line of stabling rather

than a church aisle. And lastly, while, in fine
Gothic buildings, the entire perspective con-
cludes itself gloriously in the high and distant
apse, here the nave is cut across sharply by a
line of ten chapels, the apse being only a tall
recess in the midst of them, so that, strictly
speaking, the church is not of the form of a
cross, but of a letter T.

Can this clumsy and ungraceful arrangement
be indeed the design of the renowned Arnolfo?

Yes, this is purest Arnolfo Gothic; not
beautiful by any means; but deserving, never-
theless, our thoughtfulest examination. We
will trace its complete character another day;
just now we are only concerned with this pre-
Christian form of the letter T, insisted upon
in the lines of chapels.

Respecting which you are to observe, that
the first Christian churches in the catacombs
took the form of a blunt cross naturally; a
square chamber having a vaulted recess on
each side; then the Byzantine churches were
structurally built in the form of an equal cross;
while the heraldic and other ornamental equal-
armed crosses are partly signs of glory and vic-
tory, partly of light, and divine spiritual pres-
ence.

But the Franciscans and Dominicans saw in

the cross no sign of triumph, but of trial.*
The wounds of their Master were to be their

*I have never obtained time for any right study of
early Christian church-discipline,—nor am I sure to how
many other causes the choice of the form of the basilica
may be occasionally attributed, or by what other com-
munities it may be made. Symbolism, for instance, has
most power with the Franciscans, and convenience for
preaching with the Dominicans; but in all cases, and in
all places, the transition from the close tribune to the
brightly-lighted apse, indicates the change in Christian
feeling between regarding a church as a place for public
judgment or teaching, or a place for private prayer and
congregational praise. The following passage from the
Dean of Westminster's perfect history of his Abbey
ought to be read also in the Florentine church:—"The
nearest approach to Westminster Abbey in this aspect is
the church of Santa Croce at Florence. There, as here,
the present destination of the building was no part of
the original design, but was the result of various con-
verging causes. As the church of one of the two great
preaching orders, it had a nave large beyond all pro-
portion to its choir. That order being the Franciscan,
bound by vows of poverty, the simplicity of the worship
preserved the whole space clear from any adventitious
ornaments. The popularity of the Franciscans, espe-
cially in a convent hallowed by a visit from St. Francis
himself, drew to it not only the chief civic festivals,
but also the numerous families who gave alms to the
friars, and whose connection with their church was, for
this reason, in turn encouraged by them. In those
graves, piled with standards and achievements of the
noble families of Florence, were successfully interred—
not because of their eminence, but as members or
friends of those families—some of the most illustrious
personages of the fifteenth century. Thus it came to
pass, as if by accident, that in the vault of the Buonar-
otti was laid Michael Angelo; in the vault of the Viviani
the preceptor of one of their house, Galileo. From those
two burials the church gradually became the recognized
shrine of Italian genius."

inheritance. So their first aim was to make
what image to the cross their church might
present, distinctly that of the actual instrument
of death.

And they did this most effectually by using
the form of the letter T, that of the Furca or
Gibbet,—not the sign of peace.

Also, their churches were meant for use;
not show, nor self-glorification, nor town-glori-
fication. They wanted places for preaching,
prayer, sacrifice, burial; and had no intention
of showing how high they could build towers,
or how widely they could arch vaults. Strong
walls, and the roof of a barn,—these your
Franciscan asks of his Arnolfo. These Arnolfo
gives,—thoroughly and wisely built; the suc-
cession of gable roof being a new device for
strength, much praised in its day.

This stern humor did not last long. Arnolfo
himself had other notions; much more Cim-
abue and Giotto; most of all, Nature and
Heaven. Something else had to be taught
about Christ than that He was wounded to
death. Nevertheless, look how grand this
stern form would be, restored to its simplicity.
It is not the old church which is in itself unim-
pressive. It is the old church defaced by Va-
sari, by Michael Angelo, and by modern Flor-

ence. See those huge tombs on your right
hand and left, at the sides of the aisles, with
their alternate gable and round tops, and their
paltriest of all possible sculpture, trying to be
grand by bigness, and pathetic by expense.
Tear them all down in your imagination; fancy
the vast hall with its massive pillars,—not
painted calomel-pill color, as now, but of their
native stone, with a rough, true wood for roof,
—and a people praying beneath them, strong
in abiding, and pure in life, as their rocks and
olive forests. That was Arnolfo's Santa Croce.
Nor did his work remain long without grace.

That very line of chapels in which we found
our St. Louis shows signs of change in temper.
They have no pent-house roofs, but true
Gothic vaults: we found our four-square type
of Franciscan Law on one of them.

It is probable, then, that these chapels may
be later than the rest—even in their stonework.
In their decoration, they are so, assuredly;
belonging already to the time when the story
of St. Francis was becoming a passionate tra-
dition, told and painted everywhere with delight.

And that high recess, taking the place of
apse, in the center,—see how noble it is in the
colored shade surrounding and joining the glow
of its windows, though their form be so simple.

You are not to be amused here by patterns in balance stone, as a French or English architect would amuse you, says Arnolfo. "You are to read and think, under these severe walls of mine; immortal hands will write upon them." We will go back, therefore, into this line of manuscript chapels presently; but first, look at the two sepulchral slabs by which you are standing. That farther of the two from the west end is one of the most beautiful pieces of fourteenth century sculpture in this world; and it contains simple elements of excellence, by your understanding of which you may test your power of understanding the more difficult ones you will have to deal with presently.

It represents an old man, in the high deeply folded cap worn by scholars and gentlemen in Florence from 1300—1500, lying dead, with a book in his breast, over which his hands are folded. At his feet is this inscription: "Temporibus hic suis phylosophye atq. medicine culmen fuit Galileus de Galileis olim Bonajutis qui etiam summo in magistratu miro quodam modo rempublicam dilexit, cujus sancte memorie bene acte vite pie benedictus filius hunc tumulum patri sibi suisq. posteris edidit."

Mr. Murray tells you that the effigies "in low relief" (alas, yes, low enough now—worn

mostly into flat stones, with a trace only of the
deeper lines left, but originally in very bold
relief), with which the floor of Santa Croce is
inlaid, of which this by which you stand is
characteristic, are "interesting from the cos-
tume," but that, "except in the case of John
Ketterick, Bishop of St. David's, few of the
other names have any interest beyond the walls
of Florence." As, however, you are at pres-
ent within the walls of Florence, you may per-
haps condescend to take some interest in this
ancestor or relation of the Galileo whom Flor-
ence indeed left to be externally interesting,
and would not allow to enter in her walls.

I am not sure if I rightly place or construe the
phrase in the above inscription, "cujus sancte
memorie bene acte;" but, in main purport,
the legend runs thus: "This Galileo of the
Galilei was, in his times, the head of philos-
ophy and medicine; who also in the highest
magistracy loved the republic marvelously;
whose son, blessed in inheritance of his holy
memory and well-passed and pious life,
appointed this tomb for his father, for himself,
and for his posterity."

There is no date; but the slab immediately
behind it, nearer the western door, is of the
same style, but of later and interior work, and

bears date—I forget now of what early year in the fifteenth century.

But Florence was still in her pride; and you may observe, in this epitaph, on what it was based. That her philosophy was studied together with useful arts, and as a part of them; that the masters in these became naturally the masters in public affairs; that in such magistracy they loved the State, and neither cringed to it nor robbed it; that the sons honored their fathers, and received their fathers' honor as the most blessed inheritance. Remember the phrase "vite pie benedictus filius," to be compared with the "nos nequiores," of the declining days of all states,—chiefly now in Florence, France and England.

Thus much for the local interest of name. Next for the universal interest of the art of this tomb.

It is the crowning virtue of all great art that, however little is left of it by the injuries of time, that little will be lovely. As long as you can see anything, you can see—almost all;—so much the hand of the master will suggest of his soul.

And here you are well quit, for once, of restoration. No one cares for this sculpture; and if Florence would only thus put all her old

sculpture and painting under her feet and
simply use them for gravestones and oilcloth,
she would be more merciful to them than she
is now. Here, at least, what little is left is
true.
And, if you look long, you will find it is not
so little. That worn face is still a perfect por-
trait of the old man, though like one struck
out at a venture, with a few rough touches of
a master's chisel. And that falling drapery of
his cap is, in its few lines, faultless, and subtle
beyond description.

And now, here is a simple but most useful
test of your capacity for understanding Floren-
tine sculpture or painting. If you can see that
the lines of that cap are both right and lovely;
that the choice of the folds is exquisite in its
ornamental relations of line; and that the soft-
ness and ease of them is complete,—though
only sketched with a few dark touches,—then
you can understand Giotto's drawing, and
Botticelli's;—Donatello' s carving, and Luca's.
But if you see nothing in this sculpture, you
will see nothing in theirs, of theirs. Where
they choose to imitate flesh, or silk, or to play
any vulgar modern trick with marble—(and
they often do)—whatever, in a word, is French,
or American, or Cockney, in their work, you

can see; but what is Florentine, and forever
great—unless you can see also the beauty of
this old man in his citizen's cap,—you will see
never.

There is more in this sculpture, however,
than its simple portraiture and noble drapery.
The old man lies on a piece of embroidered
carpet; and, protected by the high relief, many
of the finer lines of this are almost uninjured;
in particular, its exquisitely-wrought fringe
and tassels are nearly perfect. And if you will
kneel down and look long at the tassels of the
cushion under the head, and the way they fill
the angles of the stone, you will—or may—
know, from this example alone, what noble
decorative sculpture is, and was, and must be,
from the days of earliest Greece to those of
latest Italy.

"Exquisitely sculptured fringe!" and you
have just been abusing sculptors who play
tricks with marble! Yes, and you cannot find
a better example, in all the museums of Eu-
rope, of the work of a man who does not play
tricks with it—than this tomb. Try to under-
stand the difference: it is a point of quite car-
dinal importance to all your future study of
sculpture.

I told you, observe, that the old Galileo was

lying on a piece of embroidered carpet. I don't think, if I had not told you, that you would have found it out for yourself. It is not so like a carpet as all that comes to.

But had it been a modern trick-sculpture, the moment you came to the tomb you would have said, "Dear me! how wonderfully that carpet is done,—it doesn't look like stone in the least —one longs to take it up and beat it to get the dust off."

Now whenever you feel inclined to speak so of a sculptured drapery, be assured, without more ado, the sculpture is base, and bad. You will merely waste your time and corrupt your taste by looking at it. Nothing is so easy as to imitate drapery in marble. You may cast a piece any day; and carve it with such subtlety that the marble shall be an absolute image of the folds. But that is not sculpture. That is mechanical manufacture.

No great sculptor, from the beginning of art to the end of it, has ever carved, or ever will, a deceptive drapery. He has neither time nor will to do it. His mason's lad may do that if he likes. A man who can carve a limb or a face never finishes inferior parts, but either with a hasty and scornful chisel, or with such

grave and strict selection of their lines as you
know at once to be imaginative, not imitative.

But if, as in this case, he wants to oppose the
simplicity of his central subject with a rich
background,—a labyrinth of ornamental lines
to relieve the severity of expressive ones,—he
will carve you a carpet, or a tree, or a rose
thicket, with their fringes and leaves and
thorns, elaborated as richly as natural ones;
but always for the sake of the ornamental form,
never of the imitation; yet, seizing the natural
character in the lines he gives, with twenty
times the precision and clearness of sight that
the mere imitator has. Examine the tassels of
the cushion, and the way they blend with the
fringe, thoroughly; you cannot possibly see
finer ornamental sculpture. Then, look at the
same tassels in the same place of the slab next
the west end of the church, and you will see a
scholar's rude imitation of a master's hand,
though in a fine school. (Notice, however, the
folds of the drapery at the feet of this figure:
they are cut so as to show the hem of the robe
within as well as without, and are fine.) Then,
as you go back to Giotto's chapel, keep to the
left, and just beyond the north door in the aisle
is the much celebrated tomb of C. Marsuppini,
by Desiderio of Settignano. It is very fine of

its kind; but there the drapery is chiefly done
to cheat you, and chased delicately to show how
finely the sculptor could chisel it. It is wholly
vulgar and mean in cast of fold. Under your
feet, as you look at it, you will tread another
tomb of the fine time, which, looking last at,
you will recognize the difference between the
false and true art, as far as there is capacity
in you at present to do so. And if you really
and honestly like the low-lying stones, and see
more beauty in them, you have also the power
of enjoying Giotto, into whose chapel we will
return to-morrow;—not to-day, for the light
must have left it by this time; and now that
you have been looking at these sculptures on
the floor you had better traverse nave and aisle
across and across; and get some idea of that
sacred field of stone. In the north transept
you will find a beautiful knight, the finest in
chiseling of all these tombs, except one by the
same hand in the south aisle just where it
enters the south transept. Examine the lines
of the Gothic niches traced above them; and
what is left of arabesque on their armor. They
are far more beautiful and tender in chivalric
conception than Donatello's St. George, which
is merely a piece of vigorous naturalism
founded on these older tombs. If you will drive

in the evening to the Chartreuse in Val d'Ema,
you may see there an uninjured example of
this slab-tomb by Donatello himself: very
beautiful; but not so perfect as the earlier ones
on which it is founded. And you may see some
fading light and shade of monastic life, among
which if you stay till the fire-flies come out in
the twilight, and thus get to sleep when you
come home, you will be better prepared for
to-morrow morning's walk—if you will take
another with me—than if you go to a party, to
talk sentiment about Italy, and hear the last
news from London and New York.

THE SECOND MORNING.

THE GOLDEN GATE.

To-day, as early as you please, and at all events before doing anything else, let us go to Giotto's own parish-church, Santa Maria Novella. If, walking from the Strozzi Palace, you look on your right for the "Way of the Beautiful Ladies," it will take you quickly there.

Do not let anything in the way of acquaintance, sacristan, or chance sight stop you in doing what I tell you. Walk straight up to the church, into the apse of it;—(you may let your eyes rest, as you walk, on the glow of its glass, only mind the step, half way;)—and lift the curtain; and go in behind the grand marble altar, giving anybody who follows you anything they want, to hold their tongues, or go away.

You know, most probably, already, that the frescos on each side of you are Ghirlandajo's. You have been told they are very fine, and if you know anything of painting, you know the portraits in them are so. Nevertheless, some-

how, you don't really enjoy these frescos, **nor** come often here, do you?

The reason of which is, that if you are a nice person, they are not nice enough for you; and if a vulgar person, not vulgar enough. But if you are a nice person, I want you to look carefully, to-day, at the two lowest, next the windows, for a few minutes, that you may better feel the art you are really to study, by its contrast with these.

On your left hand is represented the birth of the Virgin. On your right, her meeting with Elizabeth.

You can't easily see better pieces—(nowhere more pompous pieces)—of flat goldsmiths' work. Ghirlandajo was to the end of his life a mere goldsmith, with a gift of portraiture. And here he has done his best, and has put a long wall in wonderful perspective, and the whole city of Florence behind Elizabeth's house in the hill country; and a splendid bas-relief, in the style of Luca della Robbia, in St. Anne's bedroom; and he has carved all the pilasters, and embroidered all the dresses, and flourished and trumpeted into every corner; and it is all done, within just a point, as well as it can be done; and quite as well as Ghirlandajo could do it. But the point in which it just misses

3

being as well as it can bed one is the vital point.
And it is all simply—good for nothing.

Extricate yourself from the goldsmith's rub-
bish of it, and look full at the Salutation.
You will say, perhaps, at first, "What grand
and graceful figures!" Are you sure they are
graceful? Look again, and you will see their
draperies hang from them exactly as they
would from two clothes-pegs. Now, fine drap-
ery, really well drawn, as it hangs from a
clothes-peg, is always rather impressive, espe-
cially if it be disposed in large breadths and
deep folds; but that is the only grace of their
figures.

Secondly. Look at the Madonna, carefully.
You will find she is not the least meek—only
stupid,—as all the other women in the picture
are.

"St. Elizabeth, you think, is nice?" Yes;
"and she says, 'Whence is this to me, that the
mother of my Lord should come to me?' really
with a great deal of serious feeling?" Yes,
with a great deal. Well, you have looked
enough at those two. Now—just for another
minute—look at the birth of the Virgin. "A
most graceful group, (your Murray's Guide
tells you), in the attendant servants." Ex-
tremely so. Also, the one holding the child is

the water does it from a great height, without splashing, most cleverly. Also, the lady coming to ask for St. Anne, and see the baby, walks majestically and is very finely dressed. And as for that bas-relief in the style of Luca della Robbia, you might really almost think it was Luca! The very best plated goods, Master Ghirlandajo, no doubt—always on hand at your shop.

Well, now you must ask for the sacristan, who is civil and nice enough, and get him to let you into the green cloister, and then go into the less cloister opening out of it on the right, as you go down the steps; and you must ask for the tomb of the Marcheza Stiozzi Ridolfi; and in the recess behind the Marcheza's tomb—very close to the ground, and in excellent light, if the day is fine—you will see two small frescos, only about four feet wide each, in odd-shaped bits of wall—quarters of circles; representing—that on the left, the Meeting of Joachim and Anna at the Golden Gate; and that on the right, the Birth of the Virgin.

No flourish of trumpets here, at any rate, you think! No gold on the gate; and, for the birth of the Virgin—is this all! Goodness!— nothing to be seen, whatever, of bas-reliefs, rather pretty. Also, the servant pouring out

nor fine dresses, nor graceful pourings out of water, nor processions of visitors?

No. There's but one thing you can see, here, which you didn't in Ghirlandajo's fresco, unless you were very clever and looked hard for it—the Baby! And you are never likely to see a more true piece of Giotto's work in this world.

A round-faced, small-eyed little thing, tied up in a bundle!

Yes, Giotto was of opinion she must have appeared really not much else than that. But look at the servant who has just finished dressing her;—awe-struck, full of love and wonder, putting her hand softly on the child's head, who has never cried. The nurse, who has just taken her, is—the nurse, and no more: tidy in the extreme, and greatly proud and pleased; but would be as much so with any other child

Ghirlandajo's St. Anne (I ought to have told you to notice that,—you can afterward) is sitting strongly up in bed, watching, if not directing, all that is going on. Giotto's lying down on the pillow, leans her face on her hand; partly exhausted, partly in deed thought. She knows that all will be well done for the child, either by the servants, or God; she need not look after anything.

At the foot of the bed is the midwife, and a servant who has brought drink for St. Anne. The servant stops, seeing her so quiet; asking the midwife, Shall I give it her now? The midwife, her hands lifted under her robe, in the attitude of thanksgiving (with Giotto distinguishable always, though one doesn't know how, from that of prayer), answers, with her look, "Let be—she does not want anything."

At the door a single acquaintance is coming in to see the child. Of ornament, there is only the entirely simple outline of the vase which the servant carries; of color, two or three masses of sober red and pure white, with brown and gray.

That is all. And if you can be pleased with this, you can see Florence. But if not, by all means amuse yourself there, if you find it amusing, as long as you like; you can never see it.

But if indeed you are pleased, ever so little, with this fresco, think what that pleasure means. I brought you, on purpose, round, through the richest overture, and farrago of tweedledum and tweedledee, I could find in Florence; and here is a tune of four notes, on a shepherd's pipe, played by the picture of nobody; and yet you like it! You know what music is, then. Here is another little tune, by

the same player, and sweeter. I let you hear
the simplest first.

The fresco on the left hand, with the bright
blue sky, and the rosy figures! Why, anybody
might like that!

Yes; but, alas, all the blue sky is repainted.
It was blue always, however, and bright too;
and I dare say, when the fresco was first done
anybody did like it.

You know the story of Joachim and Anna, I
hope? Not that I do, myself, quite in the ins
and outs; and if you don't I'm not going to
keep you waiting while I tell it. All you need
know, and you scarcely, before this fresco,
need know so much, is, that here are an old
husband and old wife, meeting again by sur-
prise, after losing each other, and being each
in great fear;—meeting at the place where they
were told by God each to go, without knowing
what was to happen there.

"So they rushed into one another's arms, and
kissed each other."

No, says Giotto,—not that.

"They advanced to meet, in a manner con-
formable to the strictest laws of composition;
and with their draperies cast into folds which no
one until Raphael could have arranged better."

No, says Giotto,—not that.

St. Anne has moved quickest; her dress just
falls into folds sloping backward enough to
tell you so much. She has caught St. Joachim
by his mantle, and draws him to her, softly,
by that. St. Joachim lays his hand under her
arm, seeing she is like to faint, and holds her
up. They do not kiss each other—only look
into each other's eyes. And God's angel lays
his hand on their heads.

Behind them, there are two rough figures,
busied with their own affairs,—two of
Joachim's shepherds; one, bare-headed, the
other wearing the wide Florentine cap with
the falling point behind, which is exactly like
the tube of a larkspur or violet; both carrying
game, and talking to each other about—Greasy
Joan and her pot or the like. Not at all the
sort of persons whom you would have thought
in harmony with the scene;—by the laws of
the drama, according to Racine or Voltaire.

No, but according to Shakespeare, or Giotto,
these are just the kind of persons likely to be
there: as much as the angel is likely to be
there also, though you will be told nowadays
that Giotto was absurd for putting him into
the sky, of which an apothecary can always
produce the similar blue, in a bottle. And now
that you have had Shakespeare, and sundry

other men of head and heart, following the
track of this shepherd lad, you can forgive him
his grotesques in the corner. But that he
should have forgiven them to himself, after the
training he had, this is the wonder! We have
seen simple pictures enough in our day; and
therefore we think that of course shepherd
boys will sketch shepherds; what wonder is
there in that?

I can show you how in this shepherd boy it
was very wonderful indeed, if you will walk
for five minutes back into the church with me,
and up into the chapel at the end of the south
transept,—at least if the day is bright, and
you get the sacristan to undraw the window-
curtain in the transept itself. For then the
light of it will be enough to show you the
entirely authentic and most renowned work of
Giotto's master; and you will see through
what schooling the lad had gone.

A good and brave master he was, if ever boy
had one; and, as you will find when you know
really who the great men are, the master is
half their life; and well they know it—always
naming themselves from their master, rather
than their families. See then what kind of
work Giotto had been first put to. There is,
literally, not a square inch of all that panel—

some ten feet high by six or seven wide—
which is not wrought in gold and color with
the fineness of a Greek manuscript. There is
not such an elaborate piece of ornamentation
in the first page of any Gothic king's missal,
as you will find in that Madonna's throne;—
the Madonna herself is meant to be grave and
noble only, and to be attended only by angels.

And here is this saucy imp of a lad declares
his people must do without gold, and without
thrones; nay, that the Golden Gate itself shall
have no gilding, that St. Joachim and St.
Anne shall have only one angel between them;
and their servants shall have their joke, and
nobody say them nay!

It is most wonderful; and would have been
impossible, had Cimabue been a common man,
though ever so great in his own way. Nor
could I in any of my former thinking under-
stand how it was, till I saw Cimabue's own work
at Assisi; in which he shows himself, at heart,
as independent of his gold as Giotto,—even
more intense, capable of higher things than
Giotto, though of none, perhaps, so keen or
sweet. But to this day, among all the Mater
Dolorosas of Christianity, Cimabue's at Assisi is
the noblest; nor did any painter after him add
one link to the chain of thought with which he

summed the creation of the earth, and
preached its redemption.

He evidently never checked the boy, from
the first day he found him. Showed him all
he knew: talked with him of many things he
felt himself unable to paint: made him a work-
man and a gentleman,—above all, a Christian,
—yet left him—a shepherd. And Heaven had
made him such a painter, that, at his height,
the words of his epitaph are in nowise over-
wrought: "Ille ego sum, per quem pictura
extincta revixit."

A word or two, now, about the repainting
by which this *pictura extincta* has been revived
to meet existing taste. The sky is entirely
daubed over with fresh blue; yet it leaves with
unusual care the original outline of the descend-
ing angel, and of the white clouds about his
body. This idea of the angel laying his hands
on the two heads—(as a bishop at Confirma-
tion does, in a hurry; and I've seen one sweep
four together, like Arnold de Winkelied),—
partly in blessing, partly as a symbol of their
being brought together to the same place by
God,—was afterward repeated again and
again: there is one beautiful little echo of it
among the old pictures in the schools of Oxford.
This is the first occurrence of it that I know in

pure Italian painting; but the idea is Etruscan-Greek, and is used by the Etruscan sculptors of the door of the Baptistery of Pisa, of the evil angel, who "lays the heads together," of two very different persons from these—Herodias and her daughter.

Joachim, and the shepherd with the larkspur cap, are both quite safe; the other shepherd a little reinforced; the black bunches of grass, hanging about, are retouches. They were once bunches of plants drawn with perfect delicacy and care; you may see one left, faint, with heart-shaped leaves, on the highest ridge of rock above the shepherds. The whole landscape is, however, quite undecipherably changed and spoiled.

You will be apt to think at first, that if anything has been restored, surely the ugly shepherd's uglier feet have. No, not at all. Restored feet are always drawn with entirely orthodox and academical toes, like the Apollo Belvidere's. You would have admired them very much. These are Giotto's own doing, every bit; and a precious business he has had of it, trying again and again—in vain. Even hands were difficult enough to him, at this time; but feet, and bare legs! Well, he'll have a try, he thinks, and gets really a fair

line at last, when you are close to it; but, lay-
ing the light on the ground afterward, he dare
not touch this precious and dear-bought out-
line. Stops all round it, a quarter of an inch
off, with such effect as you see. But if you
want to know what sort of legs and feet he can
draw, look at our lambs, in the corner of the
fresco under the arch on your left!

And there is one on your right, though more
repainted—the little Virgin presenting herself
at the Temple,—about which I could also say
much. The stooping figure, kissing the hem
of her robe without her knowing is, as far as
I remember, first in this fresco; the origin,
itself, of the main design in all the others you
know so well (and with its steps, by the way,
in better perspective already than most of
them).

"This the original one!" you will be inclined
to exclaim, if you have any general knowledge
of the subsequent art. "This Giotto! why it's
a cheap rechauffe of Titian!" No, my friend.
The boy who tried so hard to draw those steps
in perspective had been carried down others,
to his grave, two hundred years before Titian
ran alone at Cadore. But, as surely as Venice
looks on the sea, Titian looked upon this, and
caught the reflected light of it forever.

What kind of boy is this, think you, who can make Titian his copyist,—Dante his friend? What new power is here which is to change the heart of Italy?—can you see it, feel it, writing before you these words on the faded wall?

"You shall see things—as they Are."

"And the least with the greatest, because God made them."

"And the greatest with the least, because God made you, and gave you eyes and a heart."

I. You shall see things—as they are. So easy a matter that, you think? So much more difficult and sublime to paint grand processions and golden thrones, than St. Anne faint on her pillow, and her servant at pause?

Easy or not, it is all the sight that is required of you in this world,—to see things, and men and yourself,—as they are.

II. And the least with the greatest, because God made them,—shepherd, and flock, and grass of the field, no less than the Golden Gate.

III. But also the golden gate of Heaven itself, open, and the angels of God coming down from it.

These three things Giotto taught, and men believed, in his day. Of which Faith you shall next see brighter work; only before we

leave the cloister, I want to sum for you one or
two of the instant and evident technical
changes produced in the school of Florence by
this teaching.

One of quite the first results of Giotto's
simply looking at things as they were, was his
finding out that a red thing was red, and a
brown thing brown, and a white thing white—
all over.

The Greeks had painted anything anyhow,
—gods black, horses red, lips and cheeks white;
and when the Etruscan vase expanded into a
Cimabue picture, or a Tafi mosaic, still,—
except that the Madonna was to have a blue
dress, and everything else as much gold on it
as could be managed,—there was very little
advance in notions of color. Suddenly, Giotto
threw aside all the glitter, and all the conven-
tionalism; and declared that he saw the sky
blue, the tablecloth white, and angels, when
he dreamed of them, rosy. And he simply
founded the schools of color in Italy—Venetian
and all, as I will show you to-morrow morning,
if it is fine. And what is more, nobody
discovered much about color after him.

But a deeper result of his resolve to look at
things as they were, was his getting so heartily
interested in them that he couldn't miss their

decisive moment. There is a decisive instant
in all matters; and if you look languidly, you
are sure to miss it. Nature seems always
somehow trying to make you miss it. "I will
see that through," you must say, "without
turning my head;" or you won't see the trick
of it at all. And the most significant thing in
all his work, you will find hereafter, in his
choice of moments. I will give you at once
two instances in a picture which, for other
reasons, you should quickly compare with
these frescos. Return by the Via delle Belle
Donne; keep the Casa Strozzi on your right;
and go straight on, through the market. The
Florentines think themselves so civilized, for-
sooth, for building a nuovo Lung-Arno, and
three manufactory chimneys opposite it: and
yet sell butchers' meat dripping red, peaches,
and anchovies, side by side: it is a sight to be
seen. Much more, Luca della Robbia's
Madonna in the circle above the chapel door.
Never pass near the market without looking at
it; and glance from the vegetables underneath
to Luca's leaves and lilies, that you may see
how honestly he was trying to make his clay
like the garden stuff. But to-day, you may
pass quickly on to the Uffizii, which will be
just open; and when you enter the great gal-

lery, turn to the right, and there, the first
picture you come at will be No. 6, Giotto's
"Agony in the garden."

I used to think it so dull that I could not
believe it was Giotto's. That is partly from its
dead color, which is the boy's way of telling
you it is night:—more from the subject being
one quite beyond his age, and which he felt no
pleasure in trying at. You may see he was
still a boy, for he not only cannot draw feet
yet, in the least, and scrupulously hides them
therefore; but is very hard put to it for the
hands, being obliged to draw them mostly in
the same position, — all the four fingers
together. But in the careful bunches of grass
and weeds you will see what the fresco fore-
grounds were before they got spoiled; and
there are some things he can understand
already, even about that Agony, thinking of it
in his own fixed way. Some things,—not
altogether to be explained by the old symbol
of the angel with the cup. He will try if he
cannot explain them better in those two little
pictures below; which nobody ever looks at;
the great Roman sarcophagus being put in front
of them, and the light glancing on the new
varnish so that you must twist about like a

lizard to see anything. Nevertheless, you may
make out what Giotto meant.

"The cup which my Father hath given me,
shall I not drink it?" In what was its bitter-
ness?—thought the boy. "Crucifixion?—Well,
it hurts, doubtless; but the thieves had to bear
it too, and many poor human wretches have to
bear worse on our battlefields. But"—and he
thinks, and thinks, and then he paints his
two little pictures for the predel.

They represent, of course, the sequence of
the time in Gethsemane; but see what choice
the youth made of his moments, having two
panels to fill. Plenty of choice for him—in
pain. The Flagellation—the Mocking—the
Bearing of the Cross;—all habitually given by
the Margheritones, and their school, as
extremes of pain.

"No," thinks Giotto. "There was worse than
all that. Many a good man has been mocked,
spitefully entreated, spitted on, slain. But
who was ever so betrayed? Who ever saw such
a sword thrust in his mother's heart?"

He paints, first, the laying hands on Him in
the garden, but with only two principal figures,
—Judas and Peter, of course; Judas and Peter
were always principal in the old Byzantine com-
position,—Judas giving the kiss—Peter cutting

4

off the servant's ear. But the two are here, not merely principal, but almost alone in sight, all the other figures thrown back; and Peter is not at all concerned about the servant, or his struggle with him. He has got him down,— but looks back suddenly at Judas giving the kiss. What!—you are the traitor, then—you!

"Yes," says Giotto; "and you, also, in an hour more."

The other picture is more deeply felt still. It is of Christ brought to the foot of the cross. There is no wringing of hands or lamenting crowd—no haggard signs of fainting or pain in His body. Scourging or fainting, feeble knee and torn wound,—he thinks scorn of all that, this shepherd boy. One 'executioner is hammering the wedges of the cross harder down. The other—not ungently—is taking Christ's red robe off His shoulders. And St. John, a few yards off, is keeping His mother from coming nearer. She looks down, not at Christ; but tries to come.

And now you may go on for your day's seeings through the rest of the gallery, if you will —Fornarina, and the wonderful cobbler, and all the rest of it. I don't want you any more till to-morrow morning.

But if, meantime, you will sit down,—say,

before Sandro Botticelli's "Fortitude," which
I shall want you to look at, one of these days
(No. 1299, innermost room from the Tribune),
and there read this following piece of one of
my Oxford lectures on the relation of Cimabue
to Giotto, you will be better prepared for our
work to-morrow morning in Santa Croce, and
may find something to consider of, in the
room you are in. Where, by the way, observe
that No. 1288 is a most true early Lionardo, of
extreme interest: and the savants who doubt
it are—never mind what; but sit down at
present at the feet of Fortitude, and read.

Those of my readers who have been unfor-
tunate enough to interest themselves in that
most profitless of studies—the philosophy of
art—have been at various times teased or
amused by disputes respecting the relative
dignity of the contemplative and dramatic
schools.

Contemplative, of course, being the term
attached to the system of painting things only
for the sake of their own niceness—a lady
because she is pretty, or a lion because he is
strong; and the dramatic school being that
which cannot be satisfied unless it sees some-
thing going on: which can't paint a pretty lady
unless she is being made love to, or being

murdered; and can't paint a stag or a lion unless they are being hunted, or shot, or the one eating the other.

You have always heard me—or, if not, will expect by the very tone of this sentence to hear me, now, on the whole recommend you to prefer the Contemplative school. But the comparison is always an imperfect and unjust one, unless quite other terms are introduced.

The real greatness or smallness of schools is not in their preference of inactivity to action, nor of action to inactivity. It is in their preference of worthy things to unworthy, in rest; and of kind action to unkind, in business.

A Dutchman can be just as solemnly and entirely contemplative of a lemon pip and a cheese paring, as an Italian of the Virgin in Glory. An English squire has pictures, purely contemplative, of his favorite horse—and a Parisian lady, pictures, purely contemplative, of the back and front of the last dress proposed to her in La Mode Artistique. All these works belong to the same school of silent admiration; --the vital question concerning them is, "What do you admire?"

Now, therefore, when you hear me so often saying that the Northern races—Norman and Lombard,—are active, or dramatic, in their art;

and that the Southern races — Greek and
Arabian, — are contemplative, you ought
instantly to ask farther, Active in what?
Contemplative of what? And the answer is,
The active art—Lombardic,—rejoices in hunt-
ing and fighting; the contemplative art —
Byzantine,—contemplates the mysteries of the
Christian faith.

And at first, on such answer, one would be
apt at once to conclude—all grossness must be
in the Lombard; all good in the Byzantine.
But again we should be wrong,—and extremely
wrong. For the hunting and fighting did
practically produce strong, and often virtuous,
men; while the perpetual and inactive con-
templation of what it was impossible to under-
stand, did not on the whole render the
contemplative persons, stronger, wiser, or
even more amiable. So that, in the twelfth
century, while the Northern art was only in
need of direction, the Southern was in need of
life. The North was indeed spending its
valor and virtue on ignoble objects; but the
South disgracing the noblest objects by its
want of valor and virtue.

Central stood Etruscan Florence—her root
in the earth, bound with iron and brass—wet
with the dew of heaven. Agriculture in

occupation, religious in thought, she accepted, like good ground, the good; refused, like the Rock of Fesole, the evil; directed the industry of the Northman into the arts of peace; kindled the dreams of the Byzantine with the fire of charity. Child of her peace, and exponent of her passion, her Cimabue became the interpreter to mankind of the meaning of the Birth of Christ.

We hear constantly, and think naturally, of him as of a man whose peculiar genius, in painting, suddenly reformed its principles; who suddenly painted, out of his own gifted imagination, beautiful instead of rude pictures; and taught his scholar Giotto to carry on the impulse; which we suppose thenceforward to have enlarged the resources and bettered the achievements of painting continually, up to our own time,—when the triumphs of art having been completed, and its uses ended, something higher is offered to the ambition of mankind; and Watt and Faraday initiate the Age of Manufacture and Science, as Cimabue and Giotto instituted that of Art and Imagination.

In this conception of the History of Mental and Physical culture, we much overrate the influence, though we cannot overrate the

power, of the men by whom the change seems
to have been affected. We cannot overrate
their power,—for the greatest men of any age,
those who become its leaders when there is a
great march to be begun, are indeed separated
from the average intellects of their day by a
distance which is immeasurable in any ordinary
terms of wonder.

But we far overrate their influence; because
the apparently sudden result of their labor or
invention is only the manifested fruit of the
toil and thought of many who preceded them,
and of whose names we have never heard.
The skill of Cimabue cannot be extolled too
highly; but no Madonna by his hand could
ever have rejoiced the soul of Italy, unless for
a thousand years before many a nameless
Greek and nameless Goth had adorned the
traditions, and lived in the love, of the Virgin.

In like manner, it is impossible to overrate
the sagacity, patience, or precision of the
masters in modern mechanical and scientific
discovery. But their sudden triumph, and the
unbalancing of all the world by their words,
may not in any wise be attributed to their
own power, or even to that of the facts they
have ascertained. They owe their habits and
methods of industry to the paternal example,

no less than the inherited energy, of men who long ago prosecuted the truths of nature, through the rage of war, and the adversity of superstition; and the universal and overwhelming consequences of the facts which their followers have now proclaimed, indicate only the crisis of a rapture produced by the offering of new objects of curiosity to nations who had nothing to look at; and of the amusement of novel motion and action to nations who had nothing to do.

Nothing to look at! That is indeed—you will find, if you consider of it—our sorrowful case. The vast extent of the advertising fresco of London, daily refreshed into brighter and larger frescos by its bill-stickers, cannot somehow sufficiently entertain the popular eyes. The great Mrs. Allen, with her flowing hair, and equally flowing promises, palls upon repetition, and that Madonna of the nineteenth century smiles in vain above many a borgo unrejoiced; even the excitement of the shop window, with its unattainable splendors, or too easily attainable impostures, cannot maintain itself in the wearying mind of the populace, and I find my charitable friends inviting the children, whom the streets educate only into vicious misery, to entertainments of

scientific vision, in microscope or magic
lantern; thus giving them something to look
at, such as it is;—fleas mostly; and the
stomachs of various vermin; and people with
their heads cut off and set on again;—still
something, to look at.

The fame of Cimabue rests, and justly, on
a similar charity. He gave the populace of
his day something to look at; and satisfied
their curiosity with science of something they
had long desired to know. We have contin-
ually imagined in our carelessness, that his
triumph consisted only in a new pictorial
skill; recent critical writers, unable to com-
prehend how any street populace could take
pleasure in painting, have ended by denying
his triumph altogether, and insisted that he
gave no joy to Florence; and that the "Joyful
quarter" was accidentally so named—or at
least from no other festivity than that of the
procession attending Charles of Anjou. I
proved to you, in a former lecture, that the
old tradition was true, and the delight of the
people unquestionable. But that delight was
not merely in the revelation of an art they had
not known how to practice; it was delight in
the revelation of a Madonna whom they had
not known how to love.

Again; what was revelation to them—we suppose farther and as unwisely, to have been only art in him; that in better laying of colors,—in better tracing of perspectives—in recovery of principles of classic composition— he had manufactured, as our Gothic Firms now manufacture to order, a Madonna—in whom he believed no more than they.

Not so. First of the Florentines, first of the European men—he attained in thought, and saw with spiritual eyes, exercised to discern good from evil,—the face of her who was blessed among women; and with his following hand, made visible the Magnificat of his heart.

He magnified the Maid; and Florence rejoiced in her Queen. But it was left for Giotto to make the queenship better beloved, in its sweet humiliation.

You had the Etruscan stock in Florence— Christian, or at least semi - Christian; the statue of Mars still in its streets, but with its central temple built for baptism in the name of Christ. It was a race living by agriculture; gentle, thoughtful, and exquisitely fine in handiwork. The straw bonnet of Tuscany— the Leghorn—is pure Etruscan art, young ladies:—only plaited gold of God's harvest, instead of the plaited gold of His earth.

You had then the Norman and Lombard races coming down on this: kings and hunters —splendid in war—insatiable of action. You had the Greek and Arabian races flowing from the east, bringing with them the law of the City, and the dream of the Desert.

Cimabue—Etruscan born, gave, we saw, the life of the Norman to the tradition of the Greek: eager action to holy contemplation. And what more is left for his favorite shepherd boy Giotto to do, than this, except to paint with ever-increasing skill? We fancy he only surpassed Cimabue—eclipsed by greater brightness.

Not so. The sudden and new applause of Italy would never have been won by mere increase of the already-kindled light. Giotto had wholly another work to do. The meeting of the Norman race with the Byzantine is not merely that of action with repose—not merely that of war with religion,—it is the meeting of domestic life with monastic, and of practical household sense with unpractical Desert insanity.

I have no other word to use than this last. I use it reverently, meaning a very noble thing; I do not know how far I ought to say— even a divine thing. Decide that for your-

selves. Compare the Northern farmer with
St. Francis; the palm hardened by stubbing
Thornaby waste, with the palm softened by
the imagination of the wounds of Christ. To
my own thoughts, both are divine; decide that
for yourselves; but assuredly, and without
possibility of other decision, one is, humanly
speaking, healthy; the other unhealthy; one
sane, the other—insane.

To reconcile Drama with Dream, Cimabue's
task was comparatively an easy one. But to
reconcile Sense with—I still use even this fol-
lowing word reverently—Nonsense, is not so
easy; and he who did it first,—no wonder he
has a name in the world.

I must lean, however, still more distinctly
on the word "domestic." For it is not Ration-
alism and commercial competition—Mr. Stuart
Mill's "other career for woman than that of
wife and mother"—which are reconcilable, by
Giotto or by anybody else, with divine vision.
But household wisdom, labor of love, toil upon
earth according to the law of Heaven—these
are reconcilable, in one code of glory, with
revelation in cave or island, with the endur-
ance of desolate and loveless days, with the
repose of folded hands that wait Heaven's
time.

Domestic and monastic. He was the first of
Italians—the first of Christians—who equally
knew the virtue of both lives; and who was
able to show it in the sight of men of all ranks,
—from the prince to the shepherd; and of all
powers, —from the wisest philosopher to the
simplest child.

For, note the way in which the new gift of
painting, bequeathed to him by his great
master, strengthened his hands. Before Cim-
abue, no beautiful rendering of human form
was possible; and the rude or formal types of
the Lombard and Byzantine, though they
would serve in the tumult of the chase or as
the recognized symbols of creed, could not
represent personal and domestic character.
Faces with goggling eyes and rigid lips might
be endured with ready help of imagination, for
gods, angels, saints, or hunters—or for any-
body else in scenes of recognized legend, but
would not serve for pleasant portraiture of
one's own self—or of the incidents of gentle,
actual life. And even Cimabue did not ven-
ture to leave the sphere of conventionally
reverenced dignity. He still painted—though
beautifully—only the Madonna, and the St.
Joseph, and the Christ. These he made living,

—Florence asked no more: and "Credette Cimabue nella pintura tener lo campo."

But Giotto came from the field, and saw with his simple eyes a lowlier worth. And he painted—the Madonna, and St. Joseph, and the Christ,—yes, by all means if you choose to call them so, but essentially,—Mamma, Papa and the Baby. And all Italy threw up its cap, —"Ora ha Giotto il grido."

For he defines, explains, and exalts, every sweet incident of human nature; and makes dear to daily life every mystic imagination of natures greater than our own. He reconciles, while he intensifies every virtue of domestic and monastic thought. He makes the simplest household duties sacred, and the highest religious passions serviceable and just.

THE THIRD MORNING.

BEFORE THE SOLDAN.

I promised some note of Sandro's Fortitude,
before whom I asked you to sit and read the
end of my last letter; and I've lost my own
notes about her, and forget, now, whether she
has a sword, or a mace;—it does not matter.
What is chiefly notable in her is—that you
would not, if you had to guess who she was,
take her for Fortitude at all. Everybody else's
Fortitudes announce themselves clearly and
proudly. They have tower-like shields, and
lion-like helmets—and stand firm astride on
their legs,—and are confidently ready for all
comers.

Yes;—that is your common Fortitude. Very
grand, though common. But not the highest,
by any means.

Ready for all comers, and a match for them,
—thinks the universal Fortitude;—no thanks
to her for standing so steady, then!

But Botticelli's Fortitude is no match, it may
be, for any that are coming. Worn, some-

what; and not a little weary, instead of stand-
ing ready for all comers, she is sitting,—appar-
ently in reverie, her fingers playing restlessly
and idly—nay, I think—even nervously, about
the hilt of her sword.

For her battle is not to begin to-day; nor
did it begin yesterday. Many a morn and eve
have passed since it began—and now—is this
to be the ending day of it? And if this—by
what manner of end?

That is what Sandro's Fortitude is thinking.
And the playing fingers about the sword-hilt
would fain let it fall, if it might be: and yet,
how swiftly and gladly will they close on it,
when the far-off trumpet blows, which she
will hear through all her reverie!

There is yet another picture of Sandro's
here, which you must look at before going back
to Giotto: the small Judith in the room next
the Tribune, as you return from this outer
one. It is just under Lionardo's Medusa.
She is returning to the camp of her Israel,
followed by her maid carrying the head of
Holófernes. And she walks in one of Botti-
celli's light dancing actions, her drapery all on
flutter, and her hand, like Fortitude's, light on
the sword-hilt, but daintily—not nervously,
the little finger laid over the cross of it.

And at the first glance—you will think the figure merely a piece of fifteenth-century affectation. "Judith, indeed!—say rather the daughter of Herodias, at her mincingest."

Well, yes—Botticelli is affected, in the way that all men in that century necessarily were. Much euphuism, much studied grace of manner, much formal assertion of scholarship, mingling with his force of imagination. And he likes twisting the fingers of hands about, just as Correggio does. But he never does it like Correggio, without cause.

Look at Judith again,—at her face, not her drapery,—and remember that when a man is base at the heart, he blights his virtues into weaknesses; but when he is true at the heart, he sanctifies his weaknesses in to virtues. It is a weakness of Botticelli's this love of dancing motion and waved drapery; but why has he given it full flight here?

Do you happen to know anything about Judith yourself, except that she cut off Holofernes' head; and has been made the high light of about a million of vile pictures ever since, in which the painters thought they could surely attract the public to the double show of an execution, and a pretty woman,—especially

5

with the added pleasure of hinting at pre-
viously ignoble sin?

When you go home to-day, take the pains to
write out for yourself, in the connection I here
place them, the verses underneath numbered
from the book of Judith; you will probably
think of their meaning more carefully as you
write.

Begin thus:

"Now at that time, Judith heard thereof,
which was the daughter of Merari, * * * the
son of Simeon, the son of Israel." And then
write out, consecutively, these pieces—

Chapter viii., verses 2 to 8. (Always
inclusive), and read the whole chapter.

Chapter ix., verses 1 and 5 to 7, beginning
this piece with the previous sentence, "Oh
God, oh my God, hear me also a widow."

Chapter ix., verses 11 to 14.

"	x.,	"	1 to 5.
"	xiii.,	"	6 to 10.
"	xv.,	"	11 to 13.
"	xvi.,	"	1 to 6.
"	xvi.,	"	11 to 15.
"	xvi.,	"	18 and 19.
"	xvi.,	"	23 to 25.

Now, as in many other cases of enoble
history, apocryphal and other, I do not in the

least care how far the literal facts are true.
The conception of facts, and the idea of Jewish
womanhood, are there, grand and real as a
marble statue,—possession for all ages. And
you will feel, after you have read this piece of
history, or epic poetry, with honorable care,
that there is somewhat more to be thought of
and pictured in Judith, than painters have
mostly found it in them to show you; that she
is not merely the Jewish Delilah to the
Assyrian Samson; but the mightiest, purest,
brightest type of high passion in severe
womanhood offered to our human memory.
Sandro's picture is but slight; but it is true to
her, and the only one I know that is; and
after writing out these verses, you will see why
he gives her that swift, peace fulmotion, while
you read in her face, only sweet solemnity of
dreaming thought. "My people delivered,
and by my hand; and God has been gracious
to His handmaid!" The triumph of Miriam
over a fallen host, the fire of exulting mortal
life in an immortal hour, the purity and sever-
ity of a guardian angel—all are here; and as
her servant follows, carrying indeed the head,
but invisible—(a mere thing to be carried—no
more to be so much as thought of)—she looks
only at her mistress, with intense, servile,

watchful love. Faithful, not in these days of
fear only, but hitherto in all her life, and after-
ward forever.

After you have seen it enough, look also for
a little while at Angelico's Marriage and Death
of the Virgin, in the same room; you may
afterward associate the three pictures always
together in your mind. And, looking at
nothing else to-day in the Uffizi, let us go
back to Giotto's chapel.

We must begin with this work on our left
hand, the Death of St. Francis; for it is the
key to all the rest. Let us hear first what Mr.
Crowe directs us to think of it. "In the com-
position of this scene, Giotto produced a
masterpiece, which served as a model but too
often feebly imitated by his successors. Good
arrangement, variety of character and expres-
sion in the heads, unity and harmony in the
whole, make this an exceptional work of its
kind. As a composition, worthy of the four-
teenth century, Ghirlandajo and Benedetto da
Majano both imitated, without being able to
improve it. No painter ever produced its
equal except Raphael; nor could a better be
created except in so far as regards improve-
ment in the mere rendering of form."

To these inspiring observations by the

rapturous Crowe, more cautious Cavalcasella*
appends a refrigeratering note, saying, "The
St. Francis in the glory is new, but the angels
are in part preserved. The rest has all been
more or less retouched; and no judgment can
be given as to the color of this—or any other
(!)—of these works."

You are, therefore — instructed reader —
called upon to admire a piece of art which no
painter ever produced the equal of except
Raphael; but it is unhappily deficient, accord-
ing to Crowe, in the "mere rendering of form;"
and, according to Signor Cavalcasella, "no
opinion can be given as to its color."

Warned thus of the extensive places where
the ice is dangerous, and forbidden to look
here either for form or color, you are to admire
"the variety of character and expression in the
heads." I do not myself know how these are
to be given without form or color; but there
appears to me, in my innocence, to be only one
head in the whole picture, drawn up and down
in different positions.

The "unity and harmony" of the whole—

*I venture to attribute the wiser note to Signor Ca-
valcasella because I have every reason to put real confi-
dence in his judgment. But it was impossible for any
man, engaged as he is, to go over all the ground covered
by so extensive a piece of critical work as these three
volumes contain, with effective attention.

which make this an exceptional work of its
kind—mean, I suppose, its general look of
having been painted out of a scavenger's cart;
and so we are reduced to the last article of
our creed according to Crowe,—

"In the composition of this scene Giotto
produced a masterpiece."

Well, possibly The question is, What you
mean by "composition." Which, putting
modern criticism now out of our way, I will
ask the reader to think, in front of this wreck
of Giotto, with some care.

Was it, in the first place, to Giotto, think
you, the "composition of a scene," or the con-
ception of a fact? You probably, if a fashion-
able person, have seen the apotheosis of
Margaret in Faust. You know what care is
taken, nightly, in the composition of that scene,
—how the draperies are arranged for it; the
lights turned off, and on; the fiddlestrings
taxed for their utmost tenderness; the bas-
soons exhorted to a grievous solemnity.

You don't believe, however, that any real
soul of a Margaret ever appeared to any mortal
in that manner?

Here is an apotheosis also. Composed!—
yes; figures high on the right and left, low in
the middle, etc., etc., etc.

But the important questions seem to me,
Was there ever a St. Francis?—did he ever
receive stigmata?— did his soul go up to
heaven?—did any monk see it rising?—and
did Giotto mean to tell us so? If you will be
good enough to settle these few small points
in your mind first, the "composition" will
take a wholly different aspect to you, according
to your answer.

Nor does it seem doubtful to me what your
answer, after investigation made, must be.

There assuredly was a St. Francis, whose life
and works you had better study than either
to-day's Galignani, or whatever, this year,
may supply the place of the Tichborne case, in
public interest.

His reception of the stigmata is, perhaps, a
marvelous instance of the power of imagina-
tion over physical conditions; perhaps an
equally marvellous instance of the swift change
of metaphor into tradition; but assuredly, and
beyond dispute, one of the most influential,
significant, and instructive traditions possessed
by the Church of Christ. And that, if ever
soul rose to heaven from the dead body, his
soul did so rise, is equally sure.

And, finally, Giotto believed that all he was
called on to represent, concerning St. Francis,

really had taken place, just as surely as you, if
you are a Christian, believe that Christ died
and rose again; and he represents it with all
fidelity and passion: but, as I just now said,
he is a man of supreme common sense;—has
as much humor and clearness of sight as
Chaucer, and as much dislike of falsehood in
clergy, or in professedly pious people: and in
his gravest moments he will still see and say
truly that what is fat, is fat—and what is lean,
lean—and what is hollow, empty.

His great point, however, in this fresco, is
the assertion of the reality of the stigmata
against all question. There is not only one
St. Thomas to be convinced: there are five;—
one to each wound. Of these, four are intent
only on satisfying their curiosity, and are
peering or probing; one only kisses the hand
he has lifted. The rest of the picture never
was much more than a gray drawing of a
noble burial service; of all concerned in
which, one monk, only, is worthy to see the
soul taken up to heaven; and he is evidently
just the monk whom nobody in the convent
thought anything of. (His face is all repainted;
but one can gather this much, or little, out of
it, yet.)

Of the composition, or "unity and harmony

or chapel, as a whole; to be various and
entertaining when you turn the cup round
(you turn yourself round in the chapel); and to
bend its heads and necks of figures about, as it
best can, over the hollows, and ins and outs, so
that anyhow, whether too long or too short—
possible or impossible—they may be living,
and full of grace. You will also please take it
on my word to-day—in another morning walk
you shall have proof of it—that Giotto was a
pure Etruscan-Greek of the thirteenth century:
converted indeed to worship St. Francis
instead of Heracles; but as far as vase-painting
goes, precisely the Etruscan he was before.
This is nothing else than a large, beautiful,
colored Etruscan vase you have got, inverted
over your heads like a diving-bell.*

*I observe that recent criticism is engaged in proving
all Etruscan vases to be of late manufacture, in imita-
tion of archaic Greek. And I therefore must briefly
anticipate a statement which I shall have to enforce in
following letters. Etruscan art remains in its own Ital-
ian valleys, of the Arno and upper Tiber, in one
unbroken series of work, from the seventh century
before Christ, to this hour, when the country white-
washer still scratches his plaster in Etruscan patterns.
All Florentine work of the finest kind—Luca della Rob-
bia's, Ghiberti's, Donatello's, Filippo Lippi's, Botti-
celli's, Fra Angelico's—is absolutely pure Etruscan,
merely changing its subjects, and representing the
Virgin instead of Athena, and Christ instead of Jupiter.
Every line of the Florentine chisel in the fifteenth cen-
tury is based on national principles of art which existed

Accordingly, after the quatrefoil ornamentation of the top of the bell, you get two spaces at the sides under arches, very difficult to cramp one's picture into, if it is to be a picture only; but entirely provocative of our old Etruscan instinct of ornament. And, spurred by the difficulty, and pleased by the national character of it, we put our best work into these arches, utterly neglectful of the public below,—who will see the white and red and blue spaces, at any rate, which is all they will want to see, thinks Giotto, if he ever looks down from his scaffold.

Take the highest compartment, then, on the left, looking toward the window. It was wholly impossible to get the arch filled with figures, unless they stood on each other's heads; so Giotto ekes it out with a piece of fine architecture. Raphael, in the Sposalizio, does the same, for pleasure.

Then he puts two dainty little white figures, bending on each flank, to stop up his corners.

in the seventh century before Christ; and Angelico, in his convent of St. Dominic, at the foot of the hill of Fesole, is as true an Etruscan as the builder who laid the rude stones of the wall along its crest—of which modern civilization has used the only arch that remained for cheap building stone. Luckily, I sketched it in 1845; but alas, too carelessly—never conceiving of the brutalities of modern Italy as possible.

But he puts the taller inside on the right, and outside on the left. And he puts his Greek chorus of observant and moralizing persons on each side of his main action.

Then he puts one Choragus—or leader of chorus, supporting the main action—on each side. Then he puts the main action in the middle—which is a quarrel about that white bone of contention in the center. Choragus on the right, who sees that the bishop is going to have the best of it, backs him serenely. Choragus on the left, who sees that his impetuous friend is going to get the worst of it, is pulling him back, and trying to keep him quiet. The subject of the picture, which, after you are quite sure it is good as a decoration, but not till then, you may be allowed to understand, is the following. One of St. Francis' three great virtues being Obedience, he begins his spiritual life by quarreling with his father. He, I suppose in modern terms I should say, "commercially invests" some of his father's goods in charity. His father objects to that investment; on which St. Francis runs away, taking what he can find about the house along with him. His father follows to claim his property, but finds it is all gone, already; and that St. Francis has made

friends with the Bishop of Assisi. His father
flies into an indecent passion, and declares he
will disinherit him; on which St. Francis then
and there takes all his clothes off, throws them
frantically in his father's face, and says he
has nothing more to do with clothes or father.
The good Bishop, in tears of admiration,
embraces St. Francis, and covers him with his
own mantle.

I have read the picture to you as, if Mr.
Spurgeon knew anything about art, Mr.
Spurgeon would read it,—that is to say, from
the plain, common-sense, Protestant side. If
you are content with that view of it, you may
leave the chapel, and, as far as any study of
history is concerned, Florence also; for you
can never know anything either about Giotto,
or her.

Yet do not be afraid of my re-reading it to
you from the mystic, nonsensical, and Papist-
ical side. I am going to read it to you—if
after many and many a year of thought, I am
able—as Giotto meant it; Giotto being, as far
as we know, then the man of strongest brain
and hand in Florence; the best friend of the
best religious poet of the world; and widely
differing, as his friend did also, in his views of

the world, from either Mr. Spurgeon or Pius
IX

The first duty of a child is to obey its father
and mother; as the first duty of a citizen to
obey the laws of his state. And this duty is
so strict that I believe the only limits to it are
those fixed by Isaac and Iphigenia. On the
other hand, the father and mother have also a
fixed duty to the child—not to provoke it to
wrath. I have never heard this text explained
to fathers and mothers from the pulpit, which
is curious. For it appears to me that God
will expect the parents to understand their
duty to their children, better even than chil-
dren can be expected to know their duty to
their parents.

But farther. A child's duty is to obey its
parents. It is never said anywhere in the
Bible, and never was yet said in any good or
wise book, that a man's, or woman's is.
When, precisely, a child becomes a man or a
woman, it can no more be said, than when it
should first stand on its legs. But a time
assuredly comes when it should. In great
states, children are always trying to remain
children, and the parents wanting to make
men and women of them. In vile states, the
children are always wanting to be men and

women, and the parents to keep them children.
It may be—and happy the house in which it is
so—that the father's at least equal intellect,
and older experience, may remain to the end
of his life a law to his children, not of force,
but of perfect guidance, with perfect love.
Rarely it is so; not often possible. It is as
natural for the old to be prejudiced as for the
young to be presumptuous; and, in the change
of centuries, each generation has something to
judge of for itself.

But this scene, on which Giotto has dwelt
with so great force, represents, not the child's
assertion of his independence, but his adoption
of another Father.

You must not confuse the desire of this boy
of Assisi to obey God rather than man, with
the desire of your young cockney hopeful to
have a latch-key, and a separate allowance.

No point of duty has been more miserably
warped and perverted by false priests, in all
churches, than this duty of the young to choose
whom they will serve. But the duty itself
does not the less exist; and if there be any
truth in Christianity at all, there will come,
for all true disciples, a time when they have to
take that saying to heart, "He that loveth

father or mother more than Me, is not worthy of Me."

"Loveth"—observe. There is no talk of disobeying fathers or mothers whom you do not love, or of running away from a home where you would rather not stay. But to leave the home which is your peace, and to be at enmity with those who are most dear to you,—this, if there be meaning in Christ's words, one day or other will be demanded of His true followers.

And there is meaning in Christ's words. Whatever misuse may have been made of them,—whatever false prophets—and Heaven knows there have been many—have called the young children to them, not to bless, but to curse, the assured fact remains, that if you will obey God, there will come a moment when the voice of man will be raised, with all its holiest natural authority, against you. The friend and the wise adviser—the brother and the sister—the father and the master—the entire voice of your prudent and keen-sighted acquaintance—the entire weight of the scornful stupidity of the vulgar world—for one, they will be against you, all at once. You have to obey God rather than man. The human race, with all its wisdom and love, all

6 Florence

its indignation and folly, on one side,—God
alone on the other. You have to choose.

That is the meaning of St. Francis's
renouncing his inheritance; and it is the begin-
ning of Giotto's gospel of Works. Unless this
hardest of deeds be done first,—this inheritance
of mammon and the world cast away,—all
other deeds are useless. You cannot serve,
cannot obey, God and mammon. No charities,
no obediences, no self-denials, are of any use,
while you are still at heart in conformity with
the world. You go to church, because the
world goes. You keep Sunday, because your
neighbors keep it. But you dress ridiculously,
because your neighbors ask it; and you dare
not do a rough piece of work, because your
neighbors despise it. You must renounce
your neighbor, in his riches and pride, and
remember him in his distress. That is St.
Francis's "disobedience."

And now you can understand the relation of
subjects throughout the chapel, and Giotto's
choice of them.

The roof has the symbols of the three vir-
tues of labor—Poverty, Chastity, Obedience.

A. Highest on the left side, looking to the
window. The life of St. Francis begins in his
renunciation of the world.

B. Highest on the right side. His new life is approved and ordained by the authority of the Church.

C. Central on the left side. He preaches to his own disciples.

D. Central on the right side. He preaches to the heathen.

E. Lowest on the left side. His burial.

F. Lowest on the right side. His power after death.

Besides these six subjects, there are, on the sides of the window, the four great Franciscan saints, St. Louis of France, St. Louis of Toulouse, St. Clare, and St. Elizabeth of Hungary.

So that you have in the whole series this much given you to think of: first, the law of St. Francis' conscience; then, his own adoption of it; then, the ratification of it by the Christian Church; then, his preaching it in life; then, his preaching it in death; and then, the fruit of it in his disciples.

I have only been able myself to examine, or in any right sense to see, of this code of subjects, the first, second, fourth and the St. Louis and Elizabeth. I will ask you only to look at two more of them, namely, St. Francis before the Soldan, midmost on your right, and St. Louis.

The Soldan, with an ordinary opera-glass,

you may see clearly enough; and I think it
will be first well to notice some technical
points in it.

If the little virgin on the stairs of the temple
reminded you of one composition of Titian's,
this Soldan should, I think, remind you of all
that is greatest in Titian; so forcibly, indeed,
that for my own part, if I had been told that a
careful early fresco by Titian had been recov-
ered in Santa Croe, I could have believed both
report and my own eyes more quickly than I
have been able to admit that this is indeed by
Giotto. It is so great that—had its principles
been understood—there was in reality nothing
more to be taught of art in Italy; nothing to
be invented afterwards, except Dutch effects
of light.

That there is no "effect of light," here
arrived at, I beg you at once to observe as a
most important lesson. The subject is St.
Francis challenging the Sedan's Magi,—fire-
worshipers—to pass with him through the fire,
which is blazing red at his feet. It is so hot
that the two Magi on the other side of the
throne shield their faces. But it is represented
simply as a red mass of writhing forms of
flame; and casts no fire-light whatever. There
is no ruby color on anybody's nose; there are

no black shadows under anybody's chin; there
are no Rembrandtesque gradations of gloom,
or glitterings of sword-hilt and armor.

Is this ignorance, think you, in Giotto, and
pure artlessness? He was now a man in middle
life, having passed all his days in painting, and
professedly, and almost contentiously, painting
things as he saw them. Do you suppose he
never saw fire cast fire-light?—and he the friend
of Dante! who of all poets is the most subtle
in his sense of every kind of effect of light—
though he has been thought by the public to
know that of fire only. Again and again, his
ghosts wonder that there is no shadow cast by
Dante's body; and is the poet's friend, because
a painter, likely, therefore, not to have known
that mortal substance casts shadow, and ter-
restrial flame, light? Nay, the passage in the
"Purgatorio" where the shadows from the
morning sunshine make the flames redder,
reaches the accuracy of Newtonian science;
and does Giotto, think you, all the while see
nothing of the sort?

The fact was, he saw light so intensely that
he never for an instant thought of painting it.
He knew that to paint the sun was as impos-
sible as to stop it; and he was no trickster, try-
ing to find out ways of seeming to do what he

did not. I can paint a rose,—yes; and I will.
I can't paint a red-hot coal; and I won't try
to, nor seem to. This was just as natural and
certain a process of thinking with him, as the
honesty of it, and true science, were impossible
to the false painters of the sixteenth century.

Nevertheless, what his art can honestly do to
make you feel as much as he wants you to feel,
about this fire, he will do; and that studiously.
That the fire be luminous or not, is no matter
just now. But that the fire is hot, he would
have you to know. Now, will you notice what
colors he has used in the whole picture. First,
the blue background, necessary to unite it
with the other three subjects, is reduced to the
smallest possible space. St. Francis must be
in gray, for that is his dress; also the attend-
ant of one of the Magi is in gray; but so warm,
that, if you saw it by itself, you would call it
brown. The shadow behind the throne, which
Giotto knows he can paint, and therefore does,
is gray also. The rest of the picture in at least
six-sevenths of its area—is either crimson, gold,
orange, purple, or white, all as warm as Giotto
could paint them; and set off by minute spaces
only of intense black,—the Soldan's fillet at
the shoulders, his eyes, beard, and the points

necessary in the golden pattern behind. And
the whole picture is one glow.

A single glance round at the other subjects
will convince you of the special character in
this; but you will recognize also that the four
upper subjects, in which St. Francis' life and
zeal are shown, are all in comparatively warm
colors, while the two lower ones—of the death,
and the visions after it—have been kept as
definitely sad and cold.

Necessarily you might think, being full of
monks' dresses. Not so. Was there any need
for Giotto to have put the priest at the foot of
the dead body, with the black banner stooped
over it in the shape of a grave? Might he not,
had he chosen, in either fresco, have made the
celestial visions brighter? Might not St.
Francis have appeared in the center of a celes-
tial glory to the dreaming Pope, or his soul
been seen of the poor monk, rising through
more radiant clouds? Look, however, how
radiant, in the small space allowed out of the
blue, they are in reality. You cannot any-
where see a lovelier piece of Giottesque color,
though here, you have to mourn over the
smallness of the piece, and its isolation. For
the face of St. Francis himself is repainted,
and all the blue sky; but the clouds and four

sustaining angels are hardly retouched at all,
and their irridescent and exquisitely graceful
wings are left with really very tender and deli-
cate care by the restorer of the sky. And no
one but Giotto or Turner could have painted
them.

For in all his use of opalescent and warm
color, Giotto is exactly like Turner, as, in his
swift expressional power, he is like Gainsbo-
rough. All the other Italian religious painters
work out their expression with toil; he only
can give it with a touch. All the other great
Italian colorists see only the beauty of color,
but Giotto also its brightness. And none of
the others, except Tintoret, understood to the
full its symbolic power; but with those—Giotto
and Tintoret—there is always, not only a color
harmony, but a color secret. It is not merely
to make the picture glow, but to remind you
that St. Francis preaches to a fire worshiping
king, that Giotto covers the wall with purple
and scarlet;—and above, in the dispute at
Assisi, the angry father is dressed in red, vary-
ing like passion; and the robe with which his
protector embraces St. Francis, blue, symbol-
izing the peace of Heaven. Of course certain
conventional colors were traditionally employed
by all painters: but only Giotto and Tintoret

invent a symbolism of their own for every
picture. Thus in Tintoret's picture of the fall
of the manna, the figure of God the Father is
entirely robed in white, contrary to all received
custom: in that of Moses striking the rock, it is
surrounded by a rainbow. Of Giotto's sym-
bolism in color at Assisi, I have given account
elsewhere.

You are not to think, therefore, the differ-
ence between the color of the upper and lower
frescos unintentional. The life of St. Francis
was always full of joy and triumph. His
death, in great suffering, weariness, and
extreme humility. The tradition of him
reverses that of Elijah; living, he is seen in
the chariot of fire; dying, he submits to more
than the common sorrow of death.

There is, however, much more than a differ-
ence in color between the upper and lower
frescos. There is a difference in manner which
I cannot account for; and above all, a very
singular difference in skill,—indicating, it
seems to me, that the two lower were done long
before the others, and afterward united and
harmonized with them. It is of no interest to
the general reader to pursue this question; but
one point he can notice quickly, that the lower
frescos depend much on a mere black or

brown outline of the features, while the faces above are evenly and completely painted in the most accomplished Venetian manner:—and another, respecting the management of the draperies, contains much interest for us.

Giotto never succeeded, to the very end of his days, in representing a figure lying down, and at ease. It is one of the most curious points in all his character. Just the thing which he could study from nature without the smallest hindrance, is the thing he never can paint; while subtleties of form and gesture, which depend absolutely on their momentariness, and actions in which no model can stay for an instant, he seizes with infallible accuracy.

Not only has the sleeping Pope, in the right-hand lower fresco, his head laid uncomfortably on his pillow, but all the clothes on him are in awkward angles, even Giotto's instinct for lines of drapery failing him altogether when he has to lay it on a reposing figure. But look at the folds of the Soldan's robe over his knees. None could be more beautiful or right; and it is to me wholly inconceivable that the two paintings should be within even twenty years of each other in date—the skill in the upper one is so supremely greater. We shall

find, however, more than mere truth in its
casts of drapery, if we examine them.

They are so simply right, in the figure of the
Soldan, that we do not think of them;—we see
him only, not his dress. But we see dress
first, in the figures of the discomfited Magi.

Very fully draped personages these, indeed,
—with trains, it appears, four yards long, and
bearers of them.

The one nearest the Soldan has done his
devoir as bravely as he could; would fain go
up to the fire, but cannot; is forced to shield
his face, though he has not turned back.
Giotto gives him full sweeping breadth of fold;
what dignity he can;—a man faithful to his
profession, at all events.

The next one has no such courage. Col-
lapsed altogether, he has nothing more to say
for himself or his creed. Giotto hangs the
cloak upon him, in Ghirlandajo's fashion, as
from a peg, but with ludicrous narrowness of
fold. Literally, he is a "shut-up" Magus—
closed like a fan. He turns his head away,
hopelessly. And the last Magus shows noth-
ing but his back, disappearing through the
door.

Opposed to them, in a modern work, you
would have had a St. Francis standing as high

as he could in his sandals, contemptuous,
denunciatory; magnificently showing the Magi
the door. No such thing, says Giotto. A
somewhat mean man; disappointing enough in
presence —even in feature; I do not under-
stand his gesture, pointing to his forehead—
perhaps meaning, "my life, or my head, upon
the truth of this." The attendant monk behind
him is terror-struck; but will follow his mas-
ter. The dark Moorish servants of the Magi
show no emotion—will arrange their masters'
trains as usual, and decorously sustain their
retreat.

Lastly, for the Soldan himself. In a modern
work, you would assuredly have had him star-
ing at St. Francis with his eyebrows up, or
frowning thunderously at his Magi with them
bent as far down as they would go. Neither
of these aspects does he bear, according to
Giotto. A perfect gentleman and king, he
looks on his Magi with quiet eyes of decision;
he is much the noblest person in the room—
though an infidel, the true hero of the scene,
far more than St. Francis. It is evidently the
Soldan whom Giotto wants you to think of
mainly, in this picture of Christian missionary
work.

He does not altogether take the view of the

Heathen which you would get in an Exeter
Hall meeting. Does not expatiate on their
ignorance, their blackness, or their nakedness.
Does not at all think of the Florentine Isling-
ton and Pentonville as inhabited by persons in
every respect superior to the kings of the
East; nor does he imagine every other religion
but his own to be log-worship. Probably the
people who really worship logs—whether in
Persia or Pentonville—will be left to worship
logs to their hearts' content, thinks Giotto.
But to those who worship God, and who have
obeyed the laws of heaven written in their
hearts, and numbered the stars of it visible to
them,—to these, a nearer star may rise; and a
higher God be revealed.

You are to note, therefore, that Giotto's
Soldan is the type of all noblest religion and
law, in countries where the name of Christ has
not been preached. There was no doubt what
king or people should be chosen: the country
of the three Magi had already been indicated
by the miracle of Bethlehem; and the religion
and morality of Zoroaster were the purest, in
spirit the oldest, in the heathen world. There-
fore, when Dante, in the nineteenth and
twentieth books of the Paradise, gives his final
interpretation of the law of human and divine

justice in relation to the gospel of Christ—the
lower and enslaved body of the heathen being
represented by St. Philip's convert—"Chris-
tians like these the Ethiop shall condemn,"—
the noblest state of heathenism is at once
chosen, as by Giotto: "What may the Persians
say unto your kings?" Compare also Milton,—

"At the Soldan's chair,
Defied the best of Paynim chivalry."

And now, the time is come for you to look at
Giotto's St. Louis, who is the type of a Chris-
tian king.

You would, I suppose, never have seen it at
all, unless I had dragged you here on purpose.
It was enough in the dark originally—is trebly
darkened by the modern painted glass—and
dismissed to its oblivion contentedly by Mr.
Murray's "Four saints, all much restored and
repainted," and Messrs. Crowe and Caval-
casella's serene "The St. Louis is quite new."

Now, I am the last person to call any restor-
ation whatever, judicious. Of all destructive
manias, that of restoration is the frightfullest
and foolishest. Nevertheless, what good, in
its miserable way, it can bring the poor art
scholar must now apply his common sense to
take; there is no use, because a great work
has been restored, in now passing it by alto-

gether, not even looking for what instruction
we still may find in its design, which will be
more intelligible, if the restorer has had any
conscience at all, to the ordinary spectator,
than it would have been in the faded work.
When, indeed, Mr. Murray's Guide tells you
that a building has been "magnificently
restored," you may pass the building by in
resigned despair; for that means that every
bit of the old sculpture has been destroyed,
and modern vulgar copies put up in its place.
But a restored picture or fresco will often be,
to you, more useful than a pure one; and in all
probability—if an important piece of art—it
will have been spared in many places cauti-
ously completed in others, and still assert
itself in a mysterious way—as Leonardo's
Cenacolo does—through every phase of repro-
duction.*

*For a test of your feeling in the matter, having
looked well at these two lower frescos in this chapel,
walk around into the next, and examine the lower one
on your left hand as you enter that. You will find in
your Murray that the frescos in this chapel "were also
till lately (1862) covered with whitewash;" but I hap-
pened to have a long critique of this particular picture
written in the year 1845, and I see no change in it since
then. Mr. Murray's critic also tells you to observe in it
that "the daughter of Herodias playing on a violin is
not unlike Perugino's treatment of similar subjects."
By which Mr. Murray's critic means that the male musi-
cian playing on a violin, whom, without looking either

But I can assure you, in the first place, that
St. Louis is by no means altogether·new. I
have been up at it, and found most lovely and
true color left in many parts: the crown,
which you will find, after our mornings at the
Spanish chapel, is of importance, nearly
untouched; the lines of the features and hair,

at his dress, or at the rest of the fresco, he took for the
daughter of Herodias, has a broad face. Allowing you
the full benefit of this criticism—there is still a point or
two more to be observed. This is the only fresco near
the ground in which Giotto's work is untouched, at
least, by the modern restorer. So felicitously safe it is,
that you may learn from it at once and forever, what
good fresco painting is—how quiet—how delicately clear
—how little coarsely or vulgarly attractive—how capa-
ble of the most tender light and shade, and of the most
exquisite and enduring color.

In this latter respect, this fresco stands almost alone
among the works of Giotto; the striped curtain behind
the table being wrought with a variety and fantasy of
playing color which Paul Veronese could not better at
his best.

You will find without difficulty, in spite of the faint
tints, the daughter of Herodias in the middle of the
picture—slowly moving, not dancing, to the violin music
—she herself playing on a lyre. In the farther corner
of the picture, she gives St. John's head to her mother;
the face of Herodias is almost entirely faded, which
may be a farther guarantee to you of the safety of the
rest. The subject of the Apocalypse, highest on the
right, is one of the most interesting mythic pictures in
Florence; nor do I know any other so completely ren-
dering the meaning of the scene between the woman in
the wilderness, and the Dragon enemy. But it cannot
be seen from the floor level; and I have no power of
showing its beauty in words.

though all more or less reproduced, still of
definite and notable character; and the junc-
tion throughout of added color so careful,
that the harmony of the whole, if not delicate
with its old tenderness, is at least, in its coarser
way, solemn and unbroken. Such as the figure
remains, it still possesses extreme beauty—pro-
foundest interest. And, as you can see it from
below with your glass, it leaves little to be
desired, and may be dwelt upon with more
profit than nine out of ten of the renowned pic-
tures of the Tribune or the Pitti. You will enter
into the spirit of it better if I first translate for
you a little piece from the Fioretti di San
Francesco.

"How St. Louis, King of France, went per-
sonally, in the guise of a pilgrim, to Perugia to
visit the holy Brother Giles.—St. Louis, King
of France, went on pilgrimage to visit the
sanctuaries of the world; and hearing the most
great fame of the holiness of Brother Giles,
who had been among the first companions of
St. Francis, put it in his heart, and determined
assuredly that he would visit him personally;
wherefore he came to Perugia, where was then
staying the said brother. And coming to the
gate of the place of the Brothers, with few
companions, and being unknown, he asked

7 Florence

with great earnestness for Brother Giles, tell-
ing nothing to the porter who he was that
asked. The porter, therefore, goes to Brother
Giles, and says that there is a pilgrim asking
for him at the gate. And by God it was
inspired in him and revealed that it was the
King of France; whereupon quickly with great
fervor he left his cell and ran to the gate, and
without any question asked, or ever having
seen each other before, kneeling down together
with greatest devotion, they embraced and
kissed each other with as much familiarity as
if for a long time they had held great friend-
ship; but all the while neither the one nor the
other spoke, but stayed, so embraced, with such
signs of charitable love, in silence. And so
having remained for a great while, they parted
from one another, and St. Louis went on his
way, and Brother Giles returned to his cell.
And the King being gone, one of the brethren
asked of his companion who he was, who
answered that he was the King of France. Of
which the other brothers being told, were in
the greatest melancholy because Brother Giles
had never said a word to him; and murmuring
at it, they said, "Oh, Brother Giles, wherefor
hadst thou so country manners that to so holy
a king, who had come from France to see thee

and hear from thee some good word, thou hadst spoken nothing?''

"Answered Brother Giles: 'Dearest brothers, wonder not ye at this, that neither I to him, nor he to me, could speak a word; for so soon as we had embraced, the light of the divine wisdom revealed and manifested, to me, his heart, and to him, mine; and so by divine operation we looked each in the other's heart on what we would have said to one another, and knew it better far than if we had spoken with the mouth, and with more consolation, because of the defect of the human tongue, which cannot clearly express the secrets of God, and would have been for discomfort rather than comfort. And know, therefore, that the King parted from me marvelously content, and comforted in his mind.' ''

Of all which story, not a word, of course, is credible by any rational person.

Certainly not: the spirit, nevertheless, which created the story, is an entirely indisputable fact in the history of Italy and of mankind. Whether St. Louis and Brother Giles ever knelt together in the street of Perugia matters not a whit. That a king and a poor monk could be conceived to have thoughts of each other which no words could speak; and

that indeed the King's tenderness and humility
made such a tale credible to the people,—this
is what you have to meditate on here.

Nor is there any better spot in the world,—
whencesoever your pilgrim feet may have
journeyed to it, wherein to make up so much
mind as you have in you for the making, con-
cerning the nature of Kinghood and Princedom
generally; and of the forgeries and mockeries
of both which are too often manifested in their
room. For it happens that this Christian and
this Persian King are better painted here by
Giotto than elsewhere by any one, so as to
give you the best attainable conception of the
Christian and Heathen powers which have
both received, in the book which Christians
profess to reverence, the same epithet as the
King of the Jews Himself; anointed, or Chris-
tos;—and as the most perfect Christian King-
hood was exhibited in the life, partly real,
partly traditional, of St. Louis, so the most
perfect Heathen Kinghood was exemplified in
the life, partly real, partly traditional, of Cyrus
of Persia, and in the laws for human govern-
ment and education which had chief force in
his dynasty. And before the images of these
two Kings I think therefore it will be well that
you should read the charge to Cyrus, written

by Isaiah. The second clause of it, if not all, will here become memorable to you—literally illustrating, as it does, the very manner of the defeat of the Zoroastrian Magi, on which Giotto founds his Triumph of Faith. I write the leading sentences continuously; what I omit is only their amplification, which you can easily refer to at home. (Isaiah xliv. 24, to xlv. 13.)

"Thus saith the Lord, thy Redeemer, and he that formed thee from the womb. I the Lord that maketh all; that stretcheth forth the heavens, alone; that spreadeth abroad the earth, alone; that turneth wise men backward, and maketh their knowledge foolish; that confirmeth the word of his Servant, and fulfilleth the counsel of his messengers: that saith of Cyrus, He is my Shepherd, and shall perform all my pleasure, even saying to Jerusalem, 'thou shalt be built,' and to the temple, 'thy foundation shall be laid.'

"Thus saith the Lord to his Christ;—to Cyrus, whose right hand I have holden, to subdue nations before him, and I will loose the loins of Kings.

"I will go before thee, and make the crooked places straight; I will break in pieces the gates of brass, and cut in sunder the bars of

iron; and I will give thee the treasures of
darkness, and hidden riches of secret places,
that thou mayest know that I the Lord, which
call thee by thy name, am the God of Israel.

"For Jacob my servant's sake, and Israel
mine elect, I have even called thee by thy
name; I have surnamed thee, though thou
hast not known me.

"I am the Lord, and there is none else;
there is no God beside me. I girded thee,
though thou hast not known me. That they
may know, from the rising of the sun, and from
the west, that there is none beside me; I am
the Lord and there is none else. I form the
light, and create darkness; I make peace, and
create evil. I the Lord do all these things.

"I have raised him up in Righteousness, and
will direct all his ways; he shall build my city,
and let go my captives, not for price nor
reward, saith the Lord of Nations."

To this last verse, add the ordinance of Cyrus
in fulfilling it, that you may understand what
is meant by a King's being "raised up in
Righteousness," and notice, with respect to
the picture under which you stand, the Persian
King's thought of the Jewish temple.

"In the first year of the reign of Cyrus,
King Cyrus commanded that the house of the

Lord at Jerusalem should be built again, *where they do service with perpetual fire;* (the italicized sentence is Darius', quoting Cyrus' decree—the decree itself worded thus), Thus saith Cyrus, King of Persia: The Lord God of heaven hath given me all the kingdoms of the earth, and he hath charged me to build him an house at Jerusalem.

"Who is there among you of all his people? —his God be with him, and let him go up to Jerusalem which is in Judah, and let the men of his place help him with silver and with gold, and with goods and with beasts."

Between which "bringing the prisoners out of captivity" and modern liberty, free trade, and anti-slavery eloquence, there is no small interval.

To these two ideals of Kinghood, then, the boy has reached, since the day he was drawing the lamb on the stone, as Cimabue passed by. You will not find two other such, that I know of, in the west of Europe; and yet there has been many a try at the painting of crowned heads,—and King George III. and Queen Charlotte, by Sir Joshua Reynolds, are very fine, no doubt. Also your black-muzzled kings of Velasquez, and Vandyke's long-haired and white-handed ones; and Rubens' riders—in

those handsome boots. Pass such shadows of
them as you can summon, rapidly before your
memory—then look at this St. Louis.

His face—gentle, resolute, glacial-pure, thin-
cheeked; so sharp at the chin that the entire
head is almost of the form of a knight's shield
—the hair short on the forehead, falling on
each side in the old Greek-Etruscan curves of
simplest line, to the neck; I don't know if you
can see without being nearer, the difference in
the arrangement of it on the two sides—the
mass of it on the right shoulder bending
inward, while that on the left falls straight.
It is one of the pretty changes which a modern
workman would never dream of—and which
assures me the restorer has followed the old
lines rightly.

He wears a crown formed by an hexagonal
pyramid, beaded with pearls on the edges: and
walled round, above the brow, with a vertical
fortress-parapet, as it were, rising into sharp
pointed spines at the angles: it is chasing of
gold with pearl—beautiful in the remaining
work of it; the Soldan wears a crown of the
same general form; the hexagonal outline
signifying all order, strength, and royal econ-
omy. We shall see farther symbolism of this

kind, soon, by Simon Memmi, in the Spanish chapel.

I cannot tell you anything definite of the two other frescos—for I can only examine one or two pictures in a day; and never begin with one till I have done with another; and I had to leave Florence without looking at these— even so far as to be quite sure of their subjects. The central one on the left is either the twelfth subject of Assisi—St. Francis in Ecstasy;* or the eighteenth, the Apparition of St. Francis at Arles;† while the lowest on the right may admit choice between two subjects in each half of it: my own reading of them would be—that they are the twenty-first and twenty-fifth subjects of Assisi, the Dying Friar‡ and Vision of Pope Gregory IX; but Crowe and Cavalcasella may be right in their

*"Represented" (next to St. Francis before the Soldan, at Assisi) "as seen one night by the brethren, praying, elevated from the ground, his hands extended like the cross, and surrounded by a shining cloud."—Lord Lindsay.

†"St. Anthony of Padua was preaching at a general chapter of the order, held at Arles, in 1224, when St. Francis appeared in the midst, his arms extended and in an attitude of benediction."—Lord Lindsay.

‡"A brother of the order, lying on his deathbed, saw the spirit of St. Francis rising to heaven, and springing forward, cried, 'Tarry, Father, I come with thee!' and fell back dead."—Lord Lindsay.

different interpretation;* in any case, the
meaning of the entire system of work remains
unchanged, as I have given it above.

————

*"He hesitated, before canonizing St. Francis; doubt-
ing the celestial infliction of the stigmata. St. Francis
appeared to him in a vision, and with a severe counten-
ance reproving his unbelief, opened his robe, and,
exposing the wound in his side, filled a vial with the
blood that flowed from it, and gave it to the Pope, who
awoke and found it in his hand."—Lord Lindsay.

THE FOURTH MORNING.

THE VAULTED BOOK.

As early as may be this morning, let us look for a minute or two into the cathedral:—I was going to say, entering by one of the side doors of the aisles;—but we can't do anything else, which perhaps might not strike you unless you were thinking specially of it. There are no transept doors; and one never wanders round to the desolate front.

From either of the side doors, a few paces will bring you to the middle of the nave, and to the point opposite the middle of the third arch from the west end; where you will find yourself—if well in the mid-nave—standing on a circular slab of green porphyry, which marks the former place of the grave of the bishop Zenobius. The larger inscription, on the wide circle of the floor outside of you, records the translation of his body; the smaller one round the stone at your feet—"quiescimus, domum hanc quum adimus ultimam"— is a painful truth, I suppose, to travelers like us, who never rest anywhere now, if we can help it.

Resting here, at any rate, for a few minutes, look up to the whitewashed vaulting of the compartment of the roof next the west end.

You will see nothing whatever in it worth looking at. Nevertheless, look a little longer.

But the longer you look, the less you will understand why I tell you to look. It is nothing but a whitewashed ceiling: vaulted indeed, —but so is many a tailor's garret window, for that matter. Indeed, now that you have looked steadily for a minute or so, and are used to the form of the arch, it seems to become so small that you can almost fancy it the ceiling of a good-sized lumber-room in an attic.

Having attained to this modest conception of it, carry your eyes back to the similar vault of the second compartment, nearer you. Very little further contemplation will reduce that also to the similitude of a moderately-sized attic. And then, resolving to bear, if possible—for it is worth while, —the cramp in your neck for another quarter of a minute, look right up to the third vault, over your head; which, if not, in the said quarter of a minute, reducible in imagination to a tailor's garret, will at least sink, like the two others, into the semblance of a common arched ceiling, of no serious magnitude or majesty.

Then, glance quickly down from it to the floor, and round at the space (included between the four pillars), which that vault covers.

It is sixty feet square,—four hundred square yards of pavement,—and I believe you will have to look up again more than once or twice, before you can convince yourself that the mean-looking roof is swept indeed over all that twelfth part of an acre. And still less, if I mistake not, will you, without slow proof, believe, when you turn yourself round toward the east end, that the narrow niche (it really looks scarcely more than a niche) which occupies, beyond the dome, the position of our northern choirs, is indeed the unnarrowed elongation of the nave, whose breadth extends round you like a frozen lake. From which experiments and comparisons, your conclusion, I think, will be, and I am sure it ought to be, that the most studious ingenuity could not produse a design for the interior of a building which should more completely hide its extent, and throw away every common advantage of its magnitude, than this of the Duomo of Florence.

Having arrived at this, I assure you, quite securely tenable conclusion, we will quit the

cathedral by the western door, for once, and as
quickly as we can walk, return to the Green
cloister of Sta. Maria Novella; and place our-
selves on the south side of it, so as to see as
much as we can of the entrance, on the oppo-
site side, to the so-called "Spanish Chapel."

There is, indeed, within the opposite cloister,
an arch of entrance, plain enough. But no
chapel, whatever externally manifesting itself
as worth entering. No walls, or gable, or
dome, raised above the rest of the outbuildings
—only two windows with traceries opening
into the cloister; and one story of inconspicuous
building above. You can't conceive there
should be any effect of magnitude produced in
the interior, however it has been vaulted or
decorated. It may be pretty, but it cannot
possibly look large.

Entering it, nevertheless, you will be sur-
prised at the effect of height, and disposed to
fancy that the circular window cannot surely
be the same you saw outside, looking so low.
I had to go out again, myself, to make sure
that it was.

And gradually as you let the eye follow the
sweep of the vaulting arches, from the small
central keystone-boss, with the Lamp carved
on it, to the broad capitals of the hexagonal

pillars at the angles,—there will form itself in
your mind, I think, some impression not only
of vastness in the building, but of great daring
in the builder; and at last, after closely follow-
ing out the lines of a fresco or two, and look-
ing up and up again to the colored vaults, it
will become to you literally one of the grandest
places you ever entered, roofed without a cen-
tral pillar. You will begin to wonder that
human daring ever achieved anything so mag-
nificent.

But just go out again into the cloister, and
recover knowledge of the facts. It is nothing
like so large as the blank arch which at home
we filled with brickbats or leased for a gin-shop
under the last railway we made to carry coals
to Newcastle. And if you pace the floor it
covers, you will find it is three feet less one
way, and thirty feet less the other, than that
single square of the Cathedral which was
roofed like a tailor's loft,—accurately, for I did
measure here, myself, the floor of the Spanish
chapel is fifty-seven feet by thirty-two.

I hope, after this experience, that you will
need no farther conviction of the first law of
noble building, that grandeur depends on pro-
portion and design—not, except in a quite sec-
ondary degree, on magnitude. Mere size has,

indeed, under all disadvantage, some definite
value; and so has mere splendor. Disappointed
as you may be, or at least ought to be, at first,
by St. Peter's in the end you will feel its size,
—and its brightness. These are all you can
feel in it—it is nothing more than the pump-
room at Leamington built bigger;—but the
bigness tells at last; and Corinthian pillars
whose capitals alone are ten feet high, and
their acanthus leaves, three feet six long, give
you a serious conviction of the infallibility of
the Pope, and the fallibility of the wretched
Corinthians, who invented the style indeed,
but built with capitals no bigger than hand-
baskets.

Vastness has thus its value. But the glory
of architecture is to be—whatever you wish it
to be,—lovely, or grand, or comfortable,—on
such terms as it can easily obtain. Grand, by
proportion—lovely, by imagination—comfort-
able, by ingenuity—secure, by honesty: with
such materials and in such space as you have
got to give it.

Grand—by proportion, I said: but ought to
have said by disproportion. Beauty is given by
the relation of parts—size, by their comparison.
The first secret in getting the impression of size
in this chapel is the disproportion between pil-

lar and arch. You take the pillar for granted,—
it is thick, strong, and fairly high above your
head. You look to the vault springing from it
—and it soars away, nobody knows where.

Another great, but more subtle secret is in
the inequality and immeasurability of the
curved lines; and the hiding of the form by the
color.

To begin, the room, I said, is fifty-seven feet
wide, and only thirty-two deep. It is thus
nearly one-third larger in the direction across
the line of entrance, which gives to every arch,
pointed and round, throughout the roof, a dif-
ferent spring from its neighbors.

The vaulting ribs have the simplest of all
profiles—that of a chamfered beam. I call it
simpler than even that of a square beam; for
in barking a log you cheaply get your chamfer,
and nobody cares whether the level is alike on
each side; but you must take a larger tree, and
use much more work to get it square. And it
is the same with stone.

And this profile is—fix the conditions of it,
therefore, in your mind,—venerable in the his-
tory of mankind as the origin of all Gothic
tracery-moldings; venerable in the history of
the Christian Church as that of the roof ribs,
both of the lower church of Assisi, bearing the

scroll of the precepts of St. Francis, and here
at Florence, bearing the scroll of the faith of
St. Dominic. If you cut it out in paper, and
cut the corners off farther and farther, at every
cut, you will produce a sharper profile of rib,
connected in architectural use with differently
treated styles. But the entirely venerable form
is the massive one in which the angle of the
beam is merely, as it were, secured and com-
pleted in stability by removing its too sharp
edge.

Well, the vaulting ribs, as in Giotto's vault,
then, have here, under their painting, this rude
profile: but do not suppose the vaults are
simply the shells cast over them. Look how
the ornamental borders fall on the capitals!
The plaster receives all sorts of indescribably
accommodating shapes—the painter contract-
ing and stopping his design upon it as it hap-
pens to be convenient. You can't measure any-
thing; you can't exhaust; you can't grasp,—
except one simple ruling idea, which a child
can grasp, if it is interested and intelligent:
namely, that the room has four sides with four
tales told upon them; and the roof four quar-
ters, with another four tales told on those. And
each history in the sides has its correspondent
history in the roof. Generally, in good Italian

decoration, the roof represents constant, or essential facts; the walls, consecutive histories arising out of them, or leading up to them. Thus here, the roof represents in front of you, in its main quarter, the Resurrection—the cardinal fact of Christianity; opposite (above, behind you), the Ascension; on your left hand, the descent of the Holy Spirit; on your right, Christ's perpetual presence with His Church, symbolized by His appearance on the Sea of Galilee to the disciples in the storm.

The correspondent walls represent: under the first quarter (the Resurrection), the story of the Crucifixion; under the second quarter (the Ascension), the preaching after that departure, that Christ will return—symbolized here in the Dominican church by the consecration of St. Dominic; under the third quarter (the descent of the Holy Spirit), the disciplining power of human virtue and wisdom; under the fourth quarter (St. Peter's Ship), the authority and government of the State and Church.

The order of these subjects, chosen by the Dominican monks themselves, was sufficiently comprehensive to leave boundless room for the invention of the painter. The execution of it was first intrusted to Taddeo Gaddi, the best

architectural master of Giotto's school, who
painted the four quarters of the roof entirely,
but with no great brilliancy of invention and
was beginning to go down one of the sides,
when, luckily, a man of stronger brain, his
friend, came from Siena. Taddeo thankfully
yielded the room to him; he joined his own
work to that of his less able friend in an
exquisitely pretty and complimentary way;
throwing his own greater strength into it, not
competitively, but gradually and helpfully.
When, however, he had once got himself well
joined, and softly, to the more simple work,
he put his own force on with a will; and pro-
duced the most noble piece of pictorial philos-
ophy and divinity existing in Italy.

 This pretty, and, according to all evidence
by me attainable, entirely true, tradition has
been all but lost, among the ruins of fair old
Florence, by the industry of modern mason-
critics—who, without exception, laboring under
the primal (and necessarily unconscious) dis-
advantage of not knowing good work from
bad, and never, therefore, knowing a man by
his hand or his thoughts, would be in any case
sorrowfully at the mercy of mistakes in a doc-
ument; but are tenfold more deceived by their

own vanity, and delight in overthrowing a received idea, if they can.

Farther: as every fresco of this early date has been retouched again and again, and often painted half over,—and as, if there has been the least care or respect for the old work in the restorer, he will now and then follow the old lines and match the old colors carefully in some places, while he puts in clearly recognizable work of his own in others,—two critics, of whom one knows the first man's work well, and the other the last's, will contradict each other to almost any extent on the securest grounds. And there is then no safe refuge for an uninitiated person but in the old tradition, which, if not literally true, is founded assuredly on some root of fact which you are likely to get at, if ever, through it only. So that my general directions to all young people going to Florence or Rome would be very short: "Know your first volume of Vasari, and your two first books of Livy; look about you, and don't talk, nor listen to talking."

On those terms, you may know, entering this chapel, that in Michael Angelo's time, all Florence attributed these frescos to Taddeo Gaddi and Simon Memmi.

I have studied neither of these artists myself

with any speciality of care, and cannot tell you positively, anything about them or their works. But I know good work from bad, as a cobbler knows leather, and I can tell you positively the quality of these frescos, and their relation to contemporary panel pictures; whether authentically ascribed to Gaddi, Memmi, or any one else, it is for the Florentine Academy to decide.

The roof, and the north side, down to the feet of the horizontal line of sitting figures, were originally third-rate work of the school of Giotto; the rest of the chapel was originally, and most of it is still, magnificent work of the school of Siena. The roof and north side have been heavily repainted in many places; the rest is faded and injured, but not destroyed in its most essential qualities. And now, farther, you must bear with just a little bit of tormenting history of painters.

There were two Gaddis, father and son,— Taddeo and Angelo. And there were two Memmis, brothers,—Simon and Philip.

I daresay you will find, in the modern books, that Simon's real name was Peter, and Philip's real name was Bartholomew; and Angelo's real name was Taddeo, and Taddeo's real name was Angelo; and Memmi's real name was Gaddi, and Gaddi's real name was Memmi.

You may find out all that at your leisure, after-
ward, if you like. What it is important for
you to know here, in the Spanish Chapel, is
only this much that follows :—There were cer-
tainly two persons once called Gaddi, both
rather stupid in religious matters and high art;
but one of them, I don't know or care which,
a true decorative painter of the most exquisite
skill, a perfect architect, an amiable person, and
a great lover of pretty domestic life. Vasari
says this was the father, Taddeo. He built
the Ponte Vecchio; and the old stones of it—
which if you ever look at anything on the
Ponte Vecchio but the shops, you may still see
(above those wooden pent-houses) with the
Florentine shield—were so laid by him that
they are unshaken to this day.

He painted an exquisite series of frescos at
Assisi from the Life of Christ; in which,—just
to show you what the man's nature is,—when
the Madonna has given Christ into Simeon's
arms, she can't help holding out her own arms
to him, and saying (visibly), "Won't you
come back to mamma?" The child laughs his
answer—"I love you, mamma; but I'm quite
happy just now."

Well; he, or he and his son together, painted
these four quarters of the roof of the Spanish

Chapel. They were very probably much re-
touched afterward by Antonio Veneziano, or
whomsoever Messrs. Crowe and Cavalcasella
please; but that architecture in the descent of
the Holy Ghost is by the man who painted the
north transept of Assisi, and there need be no
more talk about the matter, —for you never
catch a restorer doing his old architecture
right again. And farther, the ornamentation
of the vaulting ribs is by the man who painted
the Entombment, No. 31 in the Galerie des
Grands Tableaux, in the catalogue of the
Academy for 1874. Whether that picture is
Taddeo Gaddi's or not, as stated in the cata-
logue, I do not know; but I know the vaulting
ribs of the Spanish Chapel are painted by the
same hand.

Again: by the two brothers Memmi, one or
other, I don't know or care which, had an ugly
way of turning the eyes of his figures up and
their mouths down; of which you may see an
entirely disgusting example in the four saints
attributed to Filippo Memmi on the cross wall
of the north (called always in Murray's guide
the south, because he didn't notice the way the
church was built) transcept of Assisi. You may,
however, also see the way the mouth goes down

in the much repainted, but still characteristic No. 9 in the Uffizii.

Now I catch the wring and verjuice of this brother again and again, among the minor heads of the lower frescos in this Spanish Chapel. The head of the Queen beneath Noah, in the Limbo—(see below) is unmistakable.

Farther: one of the two brothers, I don't care which, had a way of painting leaves; of which you may see a notable example in the rod in the hand of Gabriel in that same picture of the Annunciation in the Uffizii. No Florentine painter, or any other, ever painted leaves as well as that, till you get down to Sandro Botticelli, who did them much better. But the man who painted that rod in the hand of Gabriel, painted the rod in the right hand of Logic in the Spanish Chapel,—and nobody else in Florence, or the world, could.

Farther (and this is the last of the antiquarian business) ; you see that the frescos on the roof are, on the whole, dark with much blue and red in them, the white spaces coming out strongly. This is the characteristic coloring of the partially defunct school of Giotto, becoming merely decorative, and passing into a colorist school which connected itself afterward

with the Venetians. There is an exquisite
example of all its specialities in the little
Annunciation in the Uffizii, No. 14, attributed
to Angelo Gaddi, in which you see the Madonna
is stupid, and the angel stupid, but the color
of the whole, as a piece of painted glass,
lovely; and the execution exquisite,—at once
a painter's and jeweler's; with subtle sense of
chiaroscuro underneath; (note the delicate
shadow of the Madonna's arm across her
breast).

The head of this school was (according to
Vasari) Taddeo Gaddi; and henceforward,
without further discussion, I shall speak of him
as the painter of the roof of the Spanish
Chapel,—not without suspicion, however, that
his son Angelo may hereafter turn out to have
been the better decorator, and the painter of
the frescos from the life of Christ in the north
transept of Assisi,—with such assistance as his
son or scholars might give—and such change
or destruction as time, Antonio Veneziano, or
the last operations of the Tuscan railroad com-
pany, may have effected on them.

On the other hand, you see that the frescos
on the walls aré of paler colors, the blacks
coming out of these clearly, rather than the
whites; but the pale colors, especially, for

instance, the whole of the Duomo of Florence
in that on your right, very tender and lovely.
Also, you may feel a tendency to express much
with outline, and draw, more than paint, in
the most interesting parts; while in the duller
ones, nasty green and yellow tones come out,
which prevent the effect of the whole from
being very pleasant. These characteristics
belong, on the whole, to the school of Siena;
and they indicate here the work assuredly of a
man of vast power and most refined education,
whom I shall call without further discussion,
during the rest of this and the following morn-
ing's study, Simon Memmi.

And of the grace and subtlety with which
he joined his work to that of the Gaddis, you
may judge at once by comparing the Christ
standing on the fallen gate of the Limbo, with
the Christ in the Resurrection above.
Memmi has retained the dress and imitated
the general effect of the figure in the roof so
faithfully that you suspect no difference of
mastership—nay, he has even raised the foot
in the same awkward way: but you will find
Memmi's foot delicately drawn—Taddeo's,
hard and rude: and all the folds of Memmi's
drapery cast with unbroken grace and com-
plete gradations of shade, while Taddeo's are

rigid and meager; also in the heads, generally
Taddeo's type of face is square in feature, with
massive and inelegant clusters or volutes of
hair and beard; but Memmi's delicate and long
in feature, with much divided and flowing hair,
often arranged with exquisite precision, as in
the finest Greek coins. Examine successively
in this respect only the heads of Adam, Abel,
Methuselah, and Abraham, in the Limbo, and
you will not confuse the two designers any
more. I have not had time to make out more
than the principal figures in the Limbo, of
which indeed the entire dramatic power is
centered in the Adam and Eve. The latter
dressed as a nun, in her fixed gaze on Christ,
with her hands clasped, is of extreme beauty:
and however feeble the work of any early
painter may be, in its decent and grave inof-
fensiveness it guides the imagination uner-
ringly to a certain point. How far you are
yourself capable of filling up what is left
untold, and conceiving, as a reality, Eve's first
look on this her child, depends on no painter's
skill, but on your own understanding. Just
above Eve is Abel, bearing the lamb: and
behind him Noah, between his wife and Shem:
behind them, Abraham, between Isaac and
Ishmael; (turning from Ishmael to Isaac);

tion, and not worth looking at, except for the sake of making more sure our conclusions from the first fresco). The Madonna is fixed in Byzantine stiffness, without Byzantine dignity.

III. The Descent of the Holy Ghost, on the left hand. The Madonna and disciples are gathered in an upper chamber: underneath are the Parthians, Medes, Elamites, etc., who hear them speak in their own tongues.

Three dogs are in the foreground—their mythic purpose the same as that of the two verses which affirm the fellowship of the dog in the journey and return of Tobias: namely, to mark the share of the lower animals in the gentleness given by the outpouring of the Spirit of Christ.

IV. The Church sailing on the Sea of the World. St. Peter coming to Christ on the water.

I was too little interested in the vague symbolism of this fresco to examine it with care— the rather that the subject beneath, the literal contest of the Church with the world, needed more time for study in itself alone than I had for all Florence.

On this, and the opposite side of the chapel, are represented, by Simon Memmi's hand, the teaching power of the Spirit of God, and the

saving power of the Christ of God, in the
world, according to the understanding of Flor-
ence in his time.

We will take the side of Intellect first,
beneath the pouring forth of the Holy Spirit.

In the point of the arch beneath, are the three
Evangelical Virtues. Without these, says
Florence, you can have no science. Without
Love, Faith and Hope—no intelligence.

Under these are the four Cardinal Virtues,
the entire group being thus arranged:—

<div align="center">

A

B C

D E F G

</div>

A, Charity; flames issuing from her head
and hands.

B, Faith; holds cross and shield, quenching
fiery darts. This symbol, so frequent in mod-
ern adaptation from St. Paul's address to per-
sonal faith, is rare in older art.

C, Hope, with a branch of lilies.

D, Temperance; bridles a black fish, on
which she stands.

E, Prudence, with a book.

F, Justice, with crown and baton.

G, Fortitude, with tower and sword.

Under these are the great prophets and
apostles; on the left, David, St. Paul, St.

Mark, St. John; on the right, St. Matthew, St. Luke, Moses, Isaiah, Solomon. In the midst of the Evangelists, St. Thomas Aquinas, seated on a Gothic throne.

Now observe, this throne, with all the canopies below it, and the complete representation of the Duomo of Florence opposite. are of finished Gothic of Orcagna's school—later than Giotto's Gothic. But the building in which the apostles are gathered at the Pentecost is of the early Romanesque mosaic school, with a wheel window from the duomo of Assisi, and square windows from the Baptistery of Florence. And this is always the type of architecture used by Taddeo Gaddi: while the finished Gothic could not possibly have been drawn by him, but is absolute evidence of the later hand.

Under the line of prophets, as powers summoned by their voices, are the mythic figures of the seven theological or spiritual, and the seven geological or natural sciences: and under the feet of each of them, the figure of its Captain-teacher to the world.

I had better perhaps give you the names of this entire series of figures from left to right at once. You will see presently why they are numbered in a reverse order.

9

	Beneath whom
8. Civil Law.	The Emperor Justinian.
9. Canon Law.	Pope Clement V.
10. Practical Theology.	Peter Lombard.
11. ContemplativeTheology.	Dionysius the Areopagite.
12. Dogmatic Theology.	Boethius.
13. Mystic Theology.	St. John Damascene.
14. Polemic Theology.	St. Augustine.
7. Arithmetic.	Pythagoras.
6. Geometry.	Euclid.
5. Astronomy.	Zoroaster.
4. Music.	Tubalcain.
3. Logic.	Aristotle.
2. Rhetoric.	Cicero.
1. Grammar.	Priscian.

Here, then, you have pictorially represented, the system of manly education, supposed in old Florence to be that necessarily instituted in great earthly kingdoms or republics, animated by the Spirit shed down upon the world at Pentecost. How long do you think it will take you, or ought to take, to see such a picture? We were to get to work this morning, as early as might be: you have probably allowed half an hour for Santa Maria Novella; half an hour for San Lorenzo; an hour for the museum of sculpture at the Bargello; an hour for shopping; and then it will be lunch time, and you mustn't be late, because you are to leave by the afternoon train, and must positively be in Rome to-morrow morning. Well, of your half-hour for Santa Maria Novella,—after Ghirlandajo's choir, Orcagna's transept, and Cima-

bue's Madonna, and the painted windows, have
been seen properly, there will remain, suppose,
at the utmost, a quarter of an hour for the
Spanish Chapel. That will give you two min-
utes and a half for each side, two for the ceil-
ing, and three for studying Murray's explana-
tions or mine. Two minutes and a half you
have got, then—(and I observed, during my
five weeks' work in the chapel, that English
visitors seldom gave so much)—to read this
scheme given you by Simon Memmi of human
spiritual education. In order to understand
the purport of it, in any the smallest degree,
you must summon to your memory, in the
course of these two minutes and a half, what
you happen to be acquainted with of the doc-
trines and characters of Pythagoras, Zoroaster,
Aristotle, Dionysius the Areopagite, St. Aug-
ustine, and the emperor Justinian, and having
further observed the expressions and actions
attributed by the painter to these personages,
judge how far he has succeeded in reaching a
true and worthy ideal of them, and how large
or how subordinate a part in his general
scheme of human learning he supposes their
peculiar doctrines properly to occupy. For
myself, being, to my much sorrow, now an old
person; and, to my much pride, an old-

fashioned one, I have not found my powers
either of reading or memory in the least
increased by any of Mr. Stephenson's or Mr.
Wheatstone's inventions; and though indeed I
came here from Lucca in three hours instead
of a day, which it used to take, I do not think
myself able, on that account, to see any picture
in Florence in less time that it took formerly,
or even obliged to hurry myself in any invest-
igations connected with it.

 Accordingly, I have myself taken five weeks
to see the quarter of this picture of Simon
Memmi's: and can give you a fairly good
account of that quarter, and some partial
account of a fragment or ;two of those on the
other walls: but, alas! only of their pictorial
qualities in either case; for I don't myself know
anything whatever, worth trusting to, about
Pythagoras, or Dionysius the Areopagite; and
have not had, and never shall have, probably,
any time to learn much of them; while in the
very feeblest light only,—in what the French
would express by their excellent word "lueur."
—I am able to understand something of the
characters of Zoroaster, Aristotle, and Justin-
ian. But this only increases in me the rever-
ence with which I ought to stand before the
work of a painter, who was not only a master

of his own craft, but so profound a scholar and theologian as to be able to conceive this scheme of picture and write the divine law by which Florence was to live. Which Law, written in the northern page of this Vaulted Book, we will begin quiet interpretation of, if you care to return hither, to-morrow morning.

THE FIFTH MORNING.

THE STRAIT GATE.

As you return this morning to St. Mary's,
you may as well observe—the matter before us
being concerning gates—that the western
facade of the church is of two periods. Your
Murray refers it all to the latest of these;—I
forget when, and do not care;—in which the
largest flanking columns, and the entire effect-
ive mass of the walls, with their riband mosaics
and high pediment, were built in front of, and
above, what the barbarian renaissance designer
chose to leave of the pure old Dominican
church. You may see his ungainly jointings
at the pedestals of the great columns, running
through the pretty, parti-colored base, which,
with the "Strait" Gothic doors, and the entire
lines of the fronting and flanking tombs (where
not restored by the Devil-begotten brood of
modern Florence), is of pure, and exquisitely
severe and refined, fourteenth century Gothic,
with superbly carved bearings on its shields.
The small detached line of tombs on the left,

untouched in its sweet color and living weed
ornament, I would fain have painted, stone by
stone; but one can never draw in front of a
church in these republican days; for all the
blackguard children of the neighborhood come
to howl, and throw stones, on the steps, and
the ball or stone play against these sculptured
tombs, as a dead wall adapted for that purpose
only, is incessant in the fine days when I could
have worked.

If you enter by the door most to the left, or
north, and turn immediately to the right, on
the interior of the wall of the facade is an
Annunciation, visible enough because well pre-
served, though in the dark, and extremely
pretty in its way,—of the decorated and orna-
mental school following Giotto:—I can't guess
by whom, nor does it much matter; but it is
well to look at it by way of contrast with the
delicate, intense, slightly decorated design of
Memmi,—in which, when you return into the
Spanish chapel, you will feel the dependence
for its effect on broad masses of white and pale
amber, where the decorative school would have
had mosaic of red, blue, and gold.

Our first business this morning must be to
read and understand the writing on the book
held open by St. Thomas Aquinas, for that

informs us of the meaning of the whole picture.
It is this text from the Book of Wisdom
vii. 6.

" Optavi, et datus est mihi sensus.
 Invocavi, et venit in me Spiritus Sapientiæ,
 Et preposui illam regnis et sedibus."

" I willed, and Sense was given me.
 I prayed, and the Spirit of Wisdom came upon me,
 And I set her before (preferred her to) kingdoms
 and thrones."

The common translation in our English
Apocrypha loses the entire meaning of this
passage, which—not only as the statement of
the experience of Florence in her own educa-
tion, but as universally descriptive of the pro-
cess of all noble education whatever—we had
better take pains to understand.

First, says Florence, "I willed (in sense of
resolutely desiring), and Sense was given me."
You must begin your education with the dis-
tinct resolution to know what is true, and
choice of the strait and rough road to such
knowledge. This choice is offered to every
youth and maid at some moment of their life;
—choice between the easy downward road, so
broad that we can dance down it in companies,
and the steep narrow way, which we must
enter alone. Then, and for many a day after-
ward, they need that form of persistent Option,

and Will: but day by day, the "Sense" of the rightness of what they have done, deepens on them, not in consequence of the effort, but by gift granted in reward of it. And the Sense of difference between right and wrong, and between beautiful and unbeautiful things, is confirmed in the heroic, and fulfilled in the industrious, soul.

That is the process of education in the earthly sciences, and the morality connected with them. Reward given to faithful Volition.

Next, when Moral and Physical senses are perfect, comes the desire for education in the higher world, where the senses are no more our Teachers; but the Maker of the senses. And that teaching, we cannot get by labor, but only by petition.

"Invocavi, et venit in me Spiritus Sapientiæ"—"I prayed, and the Spirit of Wisdom" (not, you observe, was given,* but) "came upon me." The personal power of Wisdom: to whom the first great Christian temple was dedicated. This higher wisdom, governing by her presence, all earthly conduct, and by her teaching, all earthly art, Florence tells you, she obtained only by prayer.

*I in careless error, wrote "was given" in "Fors Clavigera."

And these two Earthly and Divine sciences
are expressed beneath in the symbols of their
divided powers; — Seven terrestrial, Seven
celestial, whose names have been already indi-
cated to you:—in which figures I must point
out one or two technical matters, before touch-
ing their interpretation. They are all by
Simon Memmi originally; but repainted, many
of them all over, some hundred years later,—
(certainly after the discovery of America, as
you will see)—by an artist of considerable
power, and some feeling for the general action
of the figures; but of no refinement or care-
lessness. He dashes massive paint in huge
spaces over the subtle old work, puts in his
own chiarooscuro where all had been shadeless,
and his own violent color where all had been
pale, and repaints the faces so as to make them,
to his notion, prettier and more human: some
of this upper work has, however, come away
since, and the original outline, at least, is trace-
able; while in the face of the Logic, the Music,
and one or two others, the original work is
very pure. Being most interested myself in
the earthly sciences, I had a scaffolding put
up, made on a level with them, and examined
them inch by inch, and the following report
will be found accurate until next repainting.

For interpretation of them, you must always take the central figure of the Science, with the little medallion above it, and the figure below, all together. Which I proceed to do, reading first from left to right for the earthly sciences, and then from right to left the heavenly ones, to the center, where their two highest powers sit, side by side.

We begin, then, with the first in the list given above (Vaulted Book, page 144):—Grammar, in the corner farthest from the window.

1. Grammar: more properly Gammatice, "Gammatic Act," the Art of Letters or "Literature," or using the word which to some English ears will carry most weight with it,— "Scripture," and its use. The Art of faithfully reading what has been written for our learning; and of clearly writing what we would make immortal of our thoughts. Power which consists first in recognizing letters; secondly, in forming them; thirdly, in the understanding and choice of words which errorless shall express our thought. Severe exercises all reaching—very few living persons know, how far: beginning properly in childhood, then only to be truly acquired. It is wholly impossible—this I say from too sorrowful experience

—to conquer by any effort or time, habits of
the hand (much more of head and soul) with
which the vase of flesh has been formed and
filled in youth,—the law of God being that
parents shall compel the child in the day of its
obedience into habits of hand, and eye, and
soul, which, when it is old, shall not, by any
strength, or any weakness, be departed from.

"Enter ye in," therefore, says Grammatice,
"at the Strait Gate." She points through it
with her rod, holding a fruit (?) for reward, in
her left hand. The gate is very strait indeed
—her own waist no less so, her hair fastened
close. ˙She had once a white veil binding it,
which is lost. Not a gushing form of litera-
ture, this,—or in any wise disposed to sub-
scribe to Mudie's, my English friends—or even
patronize Tauchnitz editions of—what is the
last new novel you see ticketed up to-day in
Mr. Goodban's window? She looks kindly
down, nevertheless, to the three children whom
she is teaching—two boys and a girl (Qy.
Does this mean that one girl out of every two
should not be able to read or write? I am
quite willing to accept that inference, for my
own part,—should perhaps even say, two girls
out of three). This girl is of the highest
classes, crowned, her golden hair falling

behind her, the Florentine girdle round her
hips—(not waist, the object being to leave the
lungs full of play; but to keep the dress always
well down in dancing or running). The boys
are of good birth also, the nearest one with
luxuriant curly hair—only the profile of the
farther one seen. All reverent and eager.
Above, the medallion is of a figure looking at
a fountain. Underneath, Lord Lindsay says,
Priscian, and is, I doubt not, right.

Technical Points.—The figure is said by
Crowe to be entirely repainted. The dress is so
throughout, both the hands also, and the fruit,
and rod. But the eyes, mouth, hair above the
forehead, and outline of the rest, with the
faded veil, and happily, the traces left of the
children, are genuine; the strait gate per-
fectly so, in the color underneath, though rein-
forced; and the action of the entire figure is
well preserved: but there is a curious question
about both the rod and fruit. Seen close, the
former perfectly assumes the shape of folds of
dress gathered up over the raised right arm,
and I am not absolutely sure that the restorer
has not mistaken the folds—at the same time
changing a pen or style into a rod. The fruit
also I have doubts of, as fruit is not so rare at

Florence that it should be made a reward. It
is entirely and roughly repainted, and is oval
in shape. In Giotto's Charity, luckily not
restored, at Assisi, the guide-books have always
mistaken the heart she holds for an apple:—
and my own belief is that originally the Gram-
matice of Simon Memmi made with her right
hand the sign which said, "Enter ye in at the
Strait Gate," and with her left, the sign which
said, "My son, give me thine Heart."

II. Rhetoric. Next to learning how to
read and write, you are to learn to speak; and,
young ladies, and gentlemen, observe,—to
speak as little as possible, it is farther implied,
till you have learned.

In the streets of Florence at this day you
may hear much of what some people call "rhe-
toric,"—very passionate speaking indeed, and
quite "from the heart,"—such hearts as the
people have got. That is to say, you never
hear a word uttered but in a rage, either just
ready to burst, or for the most part, explosive
instantly: everybody—man, woman, or child
—roaring out their incontinent, foolish, infin-
itely contemptible opinions and wills, on every
smallest occasion, with flashing eyes, hoarsely
shrieking and wasted voices,—insane hope to

drag by vociferation whatever they would have, out of man and God.

Now consider Simon Memmi's Rhetoric. The Science of Speaking, primarily; of making oneself heard therefore: which is not to be done by shouting. She alone, of all the sciences, carries a scroll: and being a speaker gives you something to read. It is not thrust forward at you at all, but held quietly down with her beautiful depressed right hand; her left hand set coolly and strongly on her side.

And you will find that, thus, she alone of all the sciences needs no use of her hands. All the others have some important business for them. She none. She can do all with her lips, holding scroll, or bridle, or what you will, with her right hand, her left or her side.

Again, look at the talkers in the streets of Florence, and see how, being essentially unable to talk, they try to make lips of their fingers! How they poke, wave, flourish, point, jerk, shake finger and fist at their antagonists— dumb essentially, all the while, if they knew it; unpersuasive and ineffectual, as the shaking of tree branches in the wind.

You will at first think her figure ungainly and stiff. It is so, partly, the dress being more coarsely repainted than in any other of the

series. But she is meant to be both stout and
strong. What she has to say is indeed to per-
suade you, if possible; but assuredly to over-
power you. And she has not the Florentino
girdle, for she does not want to move. She
has her girdle broad at the waist—of all the
sciences, you would at first have thought, the
one that most needed breath! No, says Simon
Memmi. You want breath to run, or dance,
or fight with. But to speak!—If you know
how, you can do your work with few words;
very little of this pure Florentine air will be
enough, if you shape it rightly.

Note, also, that calm setting of her hand
against her side. You think Rhetoric should
be glowing, fervid, impetuous? No, says
Simon Memmi. Above all things,—cool.

And now let us read what is written on her
scroll:—Mulceo, dum loquor, varios induta
colores.

Her chief function, to melt; make soft, thaw
the hearts of men with kind fire; to overpower
with peace; and bring rest, with rainbow col-
ors. The chief mission of all words that they
should be of comfort.

You think the function of words is to excite?
Why, a red flag will do that, or a blast through
a brass pipe. But to give calm and gentle

heat; to be as the south wind, and the iridescent rain, to all bitterness of frost; and bring at once strength, and healing. This is the work of human lips, taught of God.

One further and final lesson is given in the medallion above. Aristotle, and too many modern rhetoricians of his school, thought there could be good speaking in a false cause. But above Simon Memmi's Rhetoric is Truth, with her mirror.

There is a curious feeling, almost innate in men, that though they are bound to speak truth, in speaking to a single person, they may lie as much as they please, provided they lie to two or more people at once. There is the same feeling about killing most people would shrink from shooting one innocent man; but will fire a mitrailleuse contentedly into an innocent regiment.

When you look down from the figure of the Science, to that of Cicero, beneath, you will at first think it entirely overthrows my conclusion that Rhetoric has no need of her hands. For Cicero, it appears, has three instead of two.

The uppermost, at his chin, is the only genuine one. That raised, with the finger up, is entirely false. That on the book, is repainted so as to defy conjecture of its original action.

10

But observe how the gesture of the true once
confirms instead of overthrowing what I have
said above. Cicero is not speaking at all, but
profoundly thinking before he speaks. It is
the most abstractedly thoughtful face to be
found among all the philosophers: and very
beautiful. The whole is under Solomon, in
the line of Prophets.

Technical Points.—These two figures have
suffered from restoration more than any others,
but the right hand of Rhetoric is still entirely
genuine, and the left, except the ends of the
fingers. The ear, and hair just above it, are
quite safe, the head well set on its original line,
but the crown of leaves rudely retouched, and
then faded. All the lower part of the figure
of Cicero has been not only repainted but
changed; the face is genuine—I believe re-
touched, but so cautiously and skillfully, that
it is probably now more beautiful than at first.

III. Logic. The science of reasoning, or
more accurately Reason herself, or pure intel-
ligence.

Science to be gained after that of Expres-
sion, says Simon Memmi; so, young people, it
appears that though you must not speak before

you have been taught how to speak, you may
yet properly speak before you have been taught
how to think.

For indeed, it is only by frank speaking that
you can learn how to think. And it is no mat-
ter how wrong the first thoughts you have may
be, provided you express them clearly;—and
are willing to have them put right.

Fortunately, nearly all of this beautiful
figure is practically safe, the outlines pure
everywhere, and the face perfect: the pretti-
est, as far as I know, which exists in Italian
art of this early date. It is subtle to the
extreme in graduations of color: the eye-brows
drawn, not with a sweep of the brush, but with
separate cross touches in the line of their
growth—exquisitely pure in arch; the nose
straight and fine; the lips—playful slightly,
proud, unerringly cut; the hair flowing in
sequent waves, ordered as if in musical time;
head perfectly upright on the shoulders; the
height of the brow completed by a crimson
frontlet set with pearls, surmounted by a fleur-
de-lys.

Her shoulders were exquisitely drawn, her
white jacket fitting close to soft, yet scarcely
rising breasts; her arms singularly strong, at
perfect rest; her hands, exquisitely delicate.

In her right, she holds a branching and leaf-
bearing rod (the syllogism); in her left, a
scorpion with double sting (the dilemma)—
more generally, the powers of rational con-
struction and dissolution.

Beneath her, Aristotle,—intense keenness of
search in his half-closed eyes.

Medallion above (less expressive than usual)
a man writing, with his head stooped.

The whole, under Isaiah, in the line of
Prophets.

Technical Points.—The only parts of this
figure which have suffered seriously in repaint-
ing are the leaves of the rod, and the scorpion.
I have no idea, as I said above, what the back-
ground once was; it is now a mere mess of
scrabbled gray, carried over the vestiges, still
with care much redeemable, of the richly orna-
mental extremity of the rod, which was a clus-
ter of green leaves on a black ground. But
the scorpion is indecipherably injured, most of
it confused repainting, mixed with the white
of the dress, the double sting emphatic enough
still, but not on the first lines.

The Aristotle is very genuine throughout,
except his hat, and I think that must be pretty
nearly on the old lines, though I cannot trace
them. They are good lines, new or old.

IV. Music. After you have learned to reason, young people, of course you will be very grave, if not dull, you think. No, says Simon Memmi. By no means anything of the kind. After learning to reason, you will learn to sing; for you will want to. There is so much reason for singing in the sweet world, when one thinks rightly of it. None for grumbling, provided always you have entered in at the strait gate. You will sing all along the road then, in a little while, in a manner pleasant for other people to hear.

This figure has been 'one of the loveliest in the series, an extreme refinement and tender severity being aimed at throughout. She is crowned, not with laurel, but with small leaves,—I am not sure what they are, being too much injured: the face thin, abstracted, wistful; the lips not far open in their low singing; the hair rippling softly on the shoulders. She plays on a small organ, richly ornamented with Gothic tracery, the down slope of it set with crockets like those of Santa Maria del Fiore. Simon Memmi means that all music must be "sacred." Not that you are never to sing anything but hymns, but that whatever is rightly called music, or work of the Muses, is divine in helping and healing.

The actions of both hands are singularly
sweet. The right is one of the loveliest things
I ever saw done in painting. She is keeping
down one note only, with her third finger, seen
under the raised fourth: the thumb just pass-
ing under; all the curves of the fingers exquis-
ite, and the pale light and shade of the rosy
flesh relieved against the ivory white and brown
of the notes. Only the thumb and end of the
forefinger are seen of the left hand, but they
indicate enough its light pressure on the bel-
lows. Fortunately, all these portions of the
fresco are absolutely intact.

Underneath, Tubal-Cain. Not Jubal, as you
would expect. Jubal is the inventor of mus-
ical instruments. Tubal-Cain, thought the old
Florentines, invented harmony. They, the
best smiths in the world, knew the differences
in tones of hammer strokes on anvil. Curi-
ously enough, the only piece of true part-sing-
ing, done beautifully and joyfully, which I
have heard this year in Italy (being south of
Alps exactly six months, and ranging from
Genoa to Palermo) was out of a busy smithy at
Perugia. Of bestial howling, and entirely
frantic vomiting up of hopelessly damned souls
through their still carnal throats, I have heard

For the association of the religion of the Magi with their own in the mind of the Florentines of this time, see "Before the Soldan."

The dress must always have been white, because of its beautiful opposition to the pruple above and that of Tubal-Cain beside it. But it has been too much repainted to be trusted anywhere, nothing left but a fold or two in the sleeves. The cast of it from the knees down is entirely beautiful, and I suppose on the old lines; but the restorer could throw a fold well when he chose. The warm light which relieves the purple of Zoroaster above, is laid in by him. I don't know if I should have liked it better, flat, as it was, against the dark purple; it seems to me quite beautiful now. The full red flush on the face of the Astronomy is the restorer's doing also. She was much paler, if not quite pale.

Under St. Luke.

Medallion, a stern man, with sickle and spade. For the flowers, and for us, when stars have risen and set such and such times— remember.

Technical Points.—Left hand globe, most of the important folds of the purple dress, eyes, mouth, hair in great part, and crown, genuine.

Golden tracery on border of dress lost; extremity of falling folds from left sleeve altered and confused, but the confusion prettily got out of. Right hand and much of face and body of dress repainted.

Zoroaster's head quite pure. Dress repainted, but carefully, leaving the hair untouched. Right hand and pen, now a common feathered quill, entirely repainted, but dexterously and with feeling. The hand was once slightly different in position, and held, most probably, a reed.

VI. Geometry. You have now learned, young ladies and gentlemen, to read, to speak, to think, to sing, and to see. You are getting old, and will have soon to think of being married; you must learn to build your house therefore. Here is your carpenter's square for you, and you may safely and wisely contemplate the ground a little, and the measures and laws relating to that, seeing you have got to abide upon it:—and that you have properly looked at the stars; not before then, lest, had you studied the ground first, you might perchance never have raised your heads from it. This is properly the science of all laws of practical labor, issuing in beauty.

She looks down, a little puzzled, greatly interested, holding her carpenter's square in her left hand, not wanting that but for practical work; following a diagram with her right.

Her beauty, altogether soft and in curves, I commend to your notice, as the exact opposite of what a vulgar designer would have imagined for her. Note the wreath of hair at the back of her head, which, though fastened by a spiral fillet, escapes at last, and flies off loose in a sweeping curve. Contemplative Theology is the only other of the sciences who has such wavy hair.

Beneath her, Euclid, in white turban. Very fine and original work throughout; but nothing of special interest in him.

Under St. Matthew.

Medallion, a soldier with a straight sword (best for science of defense), octagon shield helmet like the beehive of Canton Vaud. As the secondary use of music in feasting, so the secondary use of geometry in war—her noble art being all in sweetest peace—is shown in the medallion.

Technical Points.—It is more than fortunate that in nearly every figure the original outline of the hair is safe. Geometry's has scarcely

been retouched at all, except at the ends, once
in single knots, now in confused double ones.
The hands, girdle, most of her dresses, and her
black carpenter's square are original. Face
and breast repainted.

VII. Arithmetic. Having built your house,
young people, and understanding the light of
heaven, and the measures of earth, you may
marry—and can't do better. And here is now
your conclusive science, which you will have
to apply, all your days, to all your affairs.

The Science of Number. Infinite in solem-
nity of use in Italy at this time; including, of
course, whatever was known of the higher
abstract mathematics and mysteries of num-
bers, but reverenced especially in its vital
necessity to the prosperity of families and king-
doms, and first fully so understood here in
commercial Florence.

Her hand lifted, with two fingers bent, two
straight, solemnly enforcing on your attention
her primal law—Two and two are—four, you
observe,—not five, as those accursed usurers
think.

Under her, Pythagoras.

Above, medallion of king, with scepter and
globe, counting money. Have you ever

chanced to read carefully Carlyle's account of
the foundation of the existing Prussian empire,
in economy?

You can, at all events, consider with your-
self a little, what empire this queen of the ter-
restrial sciences must hold over the rest, if
they are to be put to good use; or what depth
and breadth of application there is in the brief
parables of the counted cost of Power, and
number of Armies.

To give a very minor, but characteristic,
instance. I have always felt that with my
intense love of the Alps, I ought to have been
able to make a drawing of Chamouni, or the
vale of Cluse, which should give people more
pleasure than a photograph; but I always
wanted to do it as I saw it, and engrave pine
for pine, and crag for crag, like Albert Durer.
I broke my strength down for many a year,
always tiring of my work, or finding the leaves
drop off, or the snow come on, before I had well
begun what I meant to do. If I had only
counted my pines first, and calculated the
number of hours necessary to do them in the
manner Durer, I should have saved the avail-
able drawing time of some five years, spent in
vain effort.

But Turner counted his pines, and did all

that could be done for them, and rested contented.

So in all the affairs of life, the arithmetical part of the business is the dominant one. How many and how much have we? How many and how much do we want? How constantly does noble Arithmetic of the finite lose itself in base Avarice of the Infinite, and in blind imagination of it! In countings of minutes, is our arithmetic ever solicitous enough? In counting our days, is she ever severe enough? How we shrink from putting, in their decades, the diminished store of them! And if we ever pray the solemn prayer that we may be taught to number them, do we even try to do it after praying?

Technical Points.—The Pythagoras almost entirely genuine. The upper figures, from this inclusive to the outer wall, I have not been able to examine thoroughly, my scaffolding not extending beyond the Geometry.

Here then we have the sum of sciences,— seven, according to the Florentine mind— necessary to the secular education of man and woman. Of these the modern average respectable English gentleman and gentlewoman

know usually only a little of the last, and
entirely hate the prudent applications of that:
being unacquainted, except as they chance
here and there to pick up a broken piece of
information, with either grammar, rhetoric,
music, astronomy, or geometry; and are not
only unacquainted with logic, or the use of
reason, themselves, but instinctively antago-
nistic to its use by anybody else.

We are now to read the series of the Divine
sciences, beginning at the opposite side, next
the window.

VIII. Civil Law. Civil, or "of citizens,"
not only as distinguished from Ecclesiastical,
but from Local law. She is the universal
Justice of the peaceful relations of men
throughout the world, therefore holds the
globe, with its three-quarters, white, as being
justly governed in her left hand.

She is also the law of eternal equity, not
erring statute; therefore holds her sword level
across her breast.

She is the foundation of all other divine
science. To know anything whatever about
God, you must begin by being Just.

Dressed in red, which in these frescos is
always a sign of power, or zeal; but her face

very calm, gentle, and beautiful. Her hair
bound close, and crowned by the royal circlet
of gold, with pure thirteenth century straw-
berry leaf ornament.

Under her, the Emperor Justinian, in blue,
with conical mitre of white and gold; the face
in profile, very beautiful. The imperial staff
in his right hand, the Institutes in his left.

Medallion, a figure, apparently in distress,
appealing for justice. (Trajan's suppliant
widow?)

Technical Points.—The three divisions of
the globe in her hand were originally inscribed
Asia, Africa, Europe. The restorer has ingen-
iously changed Af into Ame—rica. Faces,
both of the science and 'emperor, little re-
touched, nor any of the rest altered.

IX. Christian Law. After the justice which
rules men, comes that which rules the Church
of Christ. The distinction is not between
secular law, and ecclesiastical authority, but
between the equity of humanity, and the law
of Christian discipline.

In full, straight-falling, golden robe, with
white mantle over it; a church in her left hand;
her right raised, with the forefinger lifted;

(indicating heavenly source of all Christian law? or warning?)

Head-dress, a white .veil floating into folds in the air. You will find nothing in these frescos without significance; and as the escaping hair of Geometry indicates the infinite conditions of lines of the higher orders, so the floating veil here indicates that the higher relations of Christian justice are indefinable. So her golden mantle indicates that it is a curious and excellent justice beyond that which unchristian men conceive; while the severely falling lines of the folds, which form a kind of gabled niche for the head of the Pope beneath, correspond with the strictness of true Church discipline, firmer as well as more luminous statute.

Beneath, Pope Clement V., in red, lifting his hand, not in the position of benediction, but, I suppose, of injunction,—only the forefinger straight, the second a little bent, the two last quite. Note the strict level of the book; and the vertical directness of the key.

The medallion puzzles me. It looks like a figure counting money.

Technical Points.—Fairly well preserved; but the face of the science retouched; the gro-

tesquely false perspective of the Pope's tiara,
one of the most curiously naive examples of
the entirely ignorant feeling after merely
scientific truth of form which still characterized
Italian art.

Type of church interesting in its extreme
simplicity; no idea of transept, campanile, or
dome.

X. Practical Theology. The beginning of
the knowledge of God being Human Justice,
and its elements defined by Christian Law, the
application of the law so defined follows, first
with respect to man, then with respect to God.

"Render unto Cæsar the things that are
Cæsar's—and to God the things that are
God's."

We have therefore now two sciences, one of
our duty to men, the other to their Maker.

This is the first: duty to men. She holds a
circular medallion, representing Christ preach-
ing on the Mount, and points with her right
hand to the earth.

The sermon on the Mount is perfectly
expressed by the craggy pinnacle in front of
Christ, and the high dark horizon. There is
curious evidence throughout all these frescos
of Simon Memmi's having read the Gospels

with a quite clear understanding of their inner-most meaning.

I have called this science Practical Theology: —the instructive knowledge, that is to say, of what God would have us do, personally, in any given human relation: and the speaking His Gospel therefore by act. "Let your light so shine before men."

She wears a green dress, like Music her hair in the Arabian arch, with jeweled diadem.

Under David.

Medallion, Almsgiving.

Beneath her, Peter Lombard.

Technical Points.—It is curious that while the instinct of perspective was not strong enough to enable any painter at this time to forshorten a foot, it yet suggested to them the expression of elevation by raising the horizon.

I have not examined the retouching. The hair and diadem at least are genuine, the face is dignified and compassionate, and much on the old lines.

XI. Devotional Theology. Giving glory to God, or, more accurately, whatever feelings. He desires us to have toward Him, whether of affection or awe.

This is the science or method of devotion for Christians universally, just as the Practical Theology is their science or method of action.

In blue and red: a narrow black rod still traceable in the left hand; I am not sure of its meaning. ("Thy rod and Thy staff, they comfort me?") The other hand open in admiration, like Astronomy's; but Devotion's is held at her breast. Her head very characteristic of Memmi, with upturned eyes, and Arab arch in hair. Under her, Dionysius the Areopagite —mending his pen! But I am doubtful of Lord Lindsay's identification of this figure, and the action is curiously common and meaningless. It may have meant that meditative theology is essentially a writer, not a preacher.

The medallion, on the other hand, is as ingenious. A mother lifting her hands in delight at her child's beginning to take notice.

Under St. Paul.

Technical Points.—Both figures very genuine, the lower one almost entirely so. The painting of the red book is quite exemplary in fresco style.

XII. Dogmatic Theology.—After action and worship, thought becoming too wide and diffi-

cult, the need of dogma becomes felt; the asser-
tion, that is, within limited range, of the things
that are to be believed.

Since whatever pride and folly pollute Chris-
tian scholarship naturally delight in dogma, the
science itself cannot but be in a kind of dis-
grace among sensible men: nevertheless it
would be difficult to overvalue the peace and
security which have been given to humble per-
sons by forms of creed; and it is evident that
either there is no such thing as theology, or
some of its knowledge must be thus, if not
expressible, at least reducible within certain
limits of expression, so as to be protected from
misinterpretation.

In red,—again the sign of power,—crowned
with a black (once golden?) triple crown,
emblematic of the Trinity. The left hand
holding a scoop for winnowing corn; the other
points upward. "Prove all things—hold fast
that which is good, or of God."

Beneath her, Boethius.

Under St. Mark.

Medallion, female figure, laying hands on
breast.

Technical Points.—The Boethius entirely
genuine, and the painting of his black book, as

of the red one beside it, again worth notice,
showing how pleasant and interesting the com-
monest things become, when well painted.
I have not examined the upper figure.

XIII. Mystic Theology.* Monastic science,
above dogma, and attaining to new revelation
by reaching higher spiritual states.

In white robes, her left hand gloved (I don't
know why)—holding chalice. She wears a
nun's veil fastened under her chin, her hair
fastened close, like Grammar's, showing her
necessary monastic life; all states of mystic
spiritual life involving retreat from much that
is allowable in the material and practical
world.

There is no possibility of denying this fact,
infinite as the evils are which have arisen from
misuse of it. They have been chiefly induced
by persons who falsely pretended to lead
monastic life, and led it without having natural
faculty for it. But many more lamentable
errors have arisen from the pride of really
noble persons, who have thought it would be a
more pleasing thing to God to be a sibyl or a
witch, than a useful housewife. Pride is
always somewhat involved even in the true

*Blunderingly in the guide-books called "Faith!"

effort: the scarlet head-dress in the form of a horn on the forehead in the fresco indicates this, both here, and in the Contemplative Theology.

Under St. John.

Medallion unintelligible, to me. A woman laying hands on the shoulders of two small figures.

Technical Points.—More of the minute folds of the white dress left than in any other of the repainted draperies. It is curious that minute division has always in drapery, more or less, been understood as an expression of spiritual life, from the delicate folds of Athena's peplus down to the rippled edges of modern priests' white robes; Titian's breadth of fold, on the other hand, meaning for the most part bodily power. The relation of the two modes of composition was lost by Michael Angelo, who thought to express spirit by making flesh colossal.

For the rest, the figure is not of any interest, Memmi's own mind being intellectual rather than mystic.

XIV. Polemic Theology.* "Who goes forth, conquering and to conquer?"

*Blunderingly called "Charity," in the guide-books.

"For we war, not with flesh and blood," etc.

In red, as sign of power, but not in armor, because she is herself invulnerable. A close red cap, with cross for crest, instead of helmet. Bow in left hand; long arrow in right.

She partly means Aggressive Logic: compare the set of her shoulders and arms with Logic's.

She is placed the last of the Divine sciences, not as their culminating power, but as the last which can be rightly learned. You must know all the others, before you go out to battle. Whereas the general principle of modern Christendom is to go out to battle without knowing any one of the others; one of the reasons for this error, the prince of errors, being the vulgar notion that truth may be ascertained by debate! Truth is never learned, in any department of industry, by arguing, but by working, and observing. And when you have got good hold of one truth, for certain, two others will grow out of it, in a beautifully dicotyledonous fashion (which, as before noticed, is the meaning of the branch in Logic's right hand). Then, when you have got so much true knowledge as is worth fighting for, you are bound to fight for it. But not to debate about it any more.

There is, however, one further reason for Polemic Theology being put beside Mystic. It is only in some approach to mystic science that any man becomes aware of what St. Paul means by "spiritual wickedness in heavenly places;" or, in any true sense, knows the enemies of God and of man.

Beneath St. Augustine. Showing you the proper method of controversy;—perfectly firm; perfectly gentle.

You are to distinguish, of course, controversy from rebuke. The assertion of truth is to be always gentle: the chastisement of willful falsehood may be—very much the contrary indeed. Christ's sermon on the Mount is full of polemic theology, yet perfectly gentle:— "Ye have heard that it hath been said—but I say unto you;"—"And if ye salute your brethren only, what do ye more than others?" and the like. But His "Ye fools and blind, for whether is greater," is not merely the exposure of error, but rebuke of the avarice which made that error possible.

Under the throne of St. Thomas; and next to Arithmetic, of the terrestrial sciences.

Medallion, a soldier, but not interesting.

Technical Points.—Very genuine and beautiful throughout. Note the use of St. Augustine's red bands, to connect him with the full red of the upper figures; and compare the niche formed by the dress of Canon Law, above the Pope, for different artistic methods of attaining the same object,—unity of composition.

But lunch time is near, my friends, and you have that shopping to do, you know.

THE SIXTH MORNING.

THE SHEPHERD'S TOWER.

I am obliged to interrupt my account of the
Spanish chapel by the following notes on the
sculptures of Giotto's Campanile: first because
I find that inaccurate accounts of those sculp-
tures are in course of publication; and chiefly
because I cannot finish my work in the Span-
ish chapel until one of my good Oxford help-
ers, Mr. Caird, has completed some investiga-
tions he has undertaken for me upon the his-
tory connected with it. I had written my own
analysis of the fourth side, believing that in
every scene of it the figure of St. Dominic was
repeated. Mr. Caird first suggested, and has
shown me already good grounds for his belief,*
that the preaching monks represented are in
each scene intended for a different person. I
am informed also of several careless mistakes

*He wrote thus to me on 11th November last: "The
three preachers are certainly different. The first is
Dominic; the second, Peter Martyr, whom I have iden-
tified from his martyrdom on the other wall; and the
third, Aquinas."

which have got into my description of the fresco of the Sciences; and finally, another of my young helpers, Mr. Charles F. Murray,— one, however, whose help is given much in the form of antagonism,—informs me of various critical discoveries lately made, both by himself and by industrious Germans, of points respecting the authenticity of this and that, which will require notice from me: more especially he tells me of a certification that the picture in the Uffizii, of which I accepted the ordinary attribution to Giotto, is by Lorenzo Monaco,—which indeed may well be, without in the least diminishing the use to you of what I have written of its predella, and without in the least, if you think rightly of the matter, diminishing your confidence in what I tell you of Giotto generally. There is one kind of knowledge of pictures which is the artist's, and another which is the antiquary's and the picture-dealer's; the latter especially acute, and founded on very secure and wide knowledge of canvas, pigment, and tricks of touch, without, necessarily, involving any knowledge whatever of the qualities of art itself. There are few practiced dealers in the great cities of Europe whose opinion would not be more trustworthy than mine (if you could get it, mind you,) on

points of actual authenticity. But they could only tell you whether the picture was by such and such a master, and not at all what either the master or his work were good for. Thus, I have, before now, taken drawings by Varley and by Cousins for early studies by 'Turner, and have been convinced by the deal- ers that they knew better than I, as far as regarded the authenticity of those drawings; but the dealers don't know Turner, or the worth of him, so well as I, for all that. So, also, you may find me again and again mistaken among the much more confused work of the early Giottesque schools, as to the authenticity of this work or the other; but you will find (and I say it with far more sorrow than pride) that I am simply the only person who can at present tell you the real worth of any; you will find that whenever I tell you to look at a pic- ture, it is worth your pains; and whenever I tell you the character of a painter, that it is his character, discerned by me faithfully in spite of all confusion of work falsely attributed to him in which similar character may exist. Thus, when I mistook Cousins for Turner, I was looking at a piece of subtlety in the sky of which the dealer had no consciousness what- ever, which was essentially Turneresque,

but which another man might sometimes equal;
whereas the dealer might be only looking at
the quality of Whatman's paper, which Cous-
ins used, and Turner did not.

Not, in the meanwhile, to leave you quite
guideless as to the main subject of the fourth
fresco in the Spanish chapel,—the Pilgrim's
Progress of Florence,—here is a brief map of
it.

On the right, in lowest angle, St. Dominic
preaches to the group of Infidels; in the next
group toward the left, he (or some one very
like him) preaches to the Heretics: the Heretics
proving obstinate, he sets his dogs at them,
as at the fatalest of wolves, who being driven
away, the rescued lambs are gathered at the
feet of the Pope. I have copied the head of
the very pious, but slightly weak-minded, little
lamb in the center, to compare with my rough
Cumberland ones, who have had no such grave
experiences. The whole group, with the Pope
above (the niche of the Duomo joining with
and enriching the decorative power of his
mitre), is a quite delicious piece of design.

The Church being thus pacified, is seen in
worldly honor under the powers of the Spirit-
ual and Temporal Rulers. The Pope, with
Cardinal and Bishop descending in order on

his right; the Emperor, with King and Baron
descending in order on his left; the ecclesiast-
ical body of the whole Church on the right
side, and the laity,—chiefly its poets and
artists, on the left.

Then, the redeemed Church nevertheless
giving itself up to the vanities and temptations
of the world, its forgetful saints are seen feast-
ing, with their children dancing before them
(the Seven Mortal Sins, say some commenta-
tors). But the wise-hearted of them confess
their sins to another ghost of St. Dominic; and
confessed, becoming as little children, enter
hand in hand the gate of the Eternal Paradise,
crowned with flowers by the waiting angels,
and admitted by St. Peter among the serenely
joyful crowd of all the saints, above whom the
white Madonna stands reverently before the
throne. There is, so far as I know, through-
out all the schools of Christian art, no other so
perfect statement of the noble policy and relig-
ion of men.

I had intended to give the best account of it
in my power; but, when at Florence, lost all
time for writing that I might copy the group
of the Pope and Emperor for the schools of
Oxford; and the work since done by Mr. Caird
has informed me of so much, and given me, in

some of its suggestions, so much to think of,
that I believe it will be best and most just to
print at once his account of the fresco as a sup-
plement to these essays of mine, merely indicat-
ing any points on which I have objections to
raise, and so leave matters till Fors lets me see
Florence once more.

Perhaps she may, in kindness, forbid my ever
seeing it more, the wreck of it being now too
ghastly and heartbreaking to any human soul
that remembers the days of old. Forty years
ago, there was assuredly no spot of ground,
out of Palestine, in all the round world, on
which, if you knew, even but a little, the true
course of that world's history, you saw with so
much joyful reverence the dawn of morning,
as at the foot of the Tower of Giotto. For
there the traditions of faith and hope, of both
the Gentile and Jewish races, met for their
beautiful labor: the Baptistery of Florence is
the last building raised on the earth by the
descendants of the workmen taught by Dæ-
dalus: and the tower of Giotto is the loveliest
of those raised on earth under the inspiration of
the men who lifted up the tabernacle in the
wilderness. Of living Greek work there is
none after the Florentine Baptistery; of living
Christian work, none so perfect as the Tower

of Giotto; and, under the gleam and shadow of their marbles, the morning light was haunted by the ghosts of the Father of Natural Science, Galileo; of Sacred Art, Angelico, and the Master of Sacred Song. Which spot of ground the modern Florentine has made his principal hackney-coach stand and omnibus station. The hackney coaches, with their more or less farm yard-like litter of occasional hay, and smell of variously mixed horse-manure, are yet in more permissible harmony with the place than the ordinary populace of a fashionable promenade would be, with its cigars, spitting, and harlot-planned fineries; but the omnibus place of call being in front of the door of the tower, renders it impossible to stand for a moment near it, to look at the sculptures either of the eastern or southern side; while the north side is enclosed with an iron railing, and usually encumbered with lumber as well; not a soul in Florence ever caring now for sight of any piece of its old artists' work; and the mass of strangers being on the whole intent on nothing but getting the omnibus to go by steam; and so seeing the cathedral in one swift circuit, by glimpses between the puffs of it.

The front of Notre Dame of Paris was sim-ilarly turned into a coach-office when I last

12 Florence

saw it—1872. Within fifty yards of me as I
write, the Oratory of the Holy Ghost is used
for a tobacco-store, and in fine, over all Europe,
mere Caliban bestiality and Satyric ravage
staggering, drunk, and desperate, into every
once enchanted cell where the prosperity of
kingdoms ruled and the miraculousness of
beauty was shrined in peace.

Deluge of profanity, drowning dome and
tower in Stygian pool of vilest thought,—noth-
ing now left sacred, in the places where once
—nothing was profane.

For that is indeed the teaching, if you could
receive it, of the Tower of Giotto; as of all
Christian art in its day. Next to declaration
of the facts of the Gospel, its purpose (often
in actual work the eagerest) was to show the
power of the Gospel. History of Christ in due
place; yes, history of all He did, and how He
died: but then, and often, as I say, with more
animated imagination, the showing of His risen
presence in granting the harvests and guiding
the labor of the year. All sun and rain, and
length or decline of days received from His
hand; all joy, and grief, and strength, or ces-
sation of labor, indulged or endured, as in His
sight and to His glory. And the familiar
employments of the seasons, the homely toils

of the peasant, the lowliest skills of the crafts-
man, are signed always on the stones of the
Church, as the first and truest condition of sac-
rifice and offering.

Of these representations of human art under
heavenly guidance, the series of bas-reliefs
which stud the base of this tower of Giotto's
must be held certainly the chief in Europe.
At first you may be surprised at the smallness
of their scale in proportion to their masonry;
but this smallness of scale enabled the master
workmen of the tower to execute them with
their own hands; and for the rest, in the very
finest architecture, the decoration of most
precious kind is usually thought of as a jewel,
and set with space round it,—as the jewels of a
crown, or the clasp of a girdle. It is in gen-
eral not possible for a great workman to carve,
himself, a greatly conspicuous series of orna-
ment; nay, even his energy fails him in design,
when the bas-relief extends itself into incrusta-
tion, or involves the treatment of great masses
of stone. If his own does not, the spectator's
will. It would be the work of a long summer's
day to examine the over-loaded sculptures of
the Certosa of Pavia; and yet in the tired last
hour, you would be empty-hearted. Read but
these inlaid jewels of Giotto's once with patient

following; and your hour's study will give you strength for all your life. So far as you can, examine them of course on the spot; but to know them thoroughly you must have their photographs: the subdued color of the old marble fortunately keeps the lights subdued, so that the photograph may be made more tender in the shadows than is usual in its renderings of sculpture, and there are few pieces of art which may now be so well known as these, in quiet homes far away.

We begin on the western side. There are seven sculptures on the western, southern, and northern sides: six on the eastern; counting the Lamb over the entrance door of the tower, which divides the complete series into two groups of eighteen and eight. Itself, between them, being the introduction to the following eight, you must count it as the first of the terminal group; you then have the whole twenty-seven sculptures divided into eighteen and nine.

Thus lettering the groups on each side for West, South, East, and North, we have:

$$\begin{array}{cccc} \text{W.} & \text{S.} & \text{E.} & \text{N.} \\ 7 & + \ 7 & + \ 6 & + \ 7 = 27; \text{ or,} \end{array}$$

$$\begin{array}{ccc} \text{W.} & \text{S.} & \text{E.} \\ 7 & + \ 7 & + \ 4 \qquad = 18; \text{ and,} \end{array}$$

$$\begin{array}{cc} \text{E.} & \text{N.} \\ 2 & + \ 7 = 9. \end{array}$$

There is a very special reason for this division by nines; but, for convenience sake, I shall number the whole from 1 to 27, straightforwardly. And if you will have patience with me, I should like to go round the tower once and again; first observing the general meaning and connection of the subjects, and then going back to examine the technical points in each, and such minor specialties as it may be well, at the first time, to pass over.

1. The series begins, then, on the west side, with the Creation of Man. It is not the beginning of the story of Genesis; but the simple assertion that God made us, and breathed, and still breathes, into our nostrils the breath of life.

This Giotto tells you to believe as the beginning of all knowledge and all power. This he tells you to believe, as a thing which he himself knows.

He will tell you nothing but what he does know.

2. Therefore, though Giovanna Pisano and his fellow sculptors had given, literally, the taking of the rib out of Adam's side, Giotto merely gives the mythic expression of the truth he knows,—"they two shall be one flesh."

3. And though all the theologians and poets

of his time would have expected, if not de-
manded, that his next assertion, after that of
the Creation of Man, should be of the Fall of
Man, he asserts nothing of the kind. He knows
nothing of what man was. What he is, he
knows best of living men at that hour, and pro-
ceeds to say. The next sculpture is of Eve
spinning and Adam hewing the ground into
clods. Not digging; you cannot, usually, dig
but in ground already dug. The native earth
you must hew.

They are not clothed in skins. What would
have been the use of Eve spinning if she could
not weave? They wear, each, one simple piece
of drapery, Adam's knotted behind him, Eve's
fastened around her neck with a rude brooch.

Above them are an oak and an apple-tree.
Into the apple-tree a little bear is trying to
climb.

The meaning of which entire myth is, as I
read it, that men and women must both eat
their bread with toil. That the first duty of man
is to feed his family, and the first duty of the
woman to clothe it. That the trees of the field
are given us for strength and for delight, and

that the wild beasts of the field must have their share with us.*

4. The fourth sculpture, forming the center-piece of the series on the west side, is nomad pastoral life.

Jabal, the father of such as dwell in tents, and of such as have cattle, lifts the curtain of his tent to look out upon his flock. His dog watches it.

5. Jubal, the father of all such as handle the harp and organ.

That is to say, stringed and wind instruments;—the lyre and reed. The first arts (with the Jew and Greek) of the shepherd David, and shepherd Apollo.

Giotto has given him the long level trumpet, afterward adopted so grandly in the sculptures of La Robbia and Donatello. It is, I think, intended to be of wood, as now the long Swiss horn, and a long and shorter tube are bound together.

6. Tubal Cain, the instructor of every artificer in brass and iron.

Giotto represents him as sitting, fully robed,

*The oak and apple boughs are placed, with the same meaning, by Sandro Botticelli, in the lap of Zipporah. The figure of the bear is again represented by Jacopo della Quercia, on the north door of the Cathedral of Florence. I am not sure of its complete meaning.

turning a wedge of bronze on the anvil with extreme watchfulness.

These last three sculptures, observe, represent the life of the race of Cain; of those who are wanderers, and have no home. Nomad pastoral life; Nomad artistic life, Wandering Willie; yonder organ man, whom you want to send the policeman after, and the gypsy who is mending the old school-mistress' kettle on the grass, which the squire has wanted so long to take into his park from the roadside.

7. Then the last sculpture of the seven begins the story of the race of Seth, and of home life. The father of it lying drunk under his trellised vine; such the general image of civilized society, in the abstract, thinks Giotto.

With several other meanings, universally known to the Catholic world of that day,—too many to be spoken of here.

The second side of the tower represents, after this introduction, the sciences and arts of civilized or home life.

8. Astronomy. In nomad life you may serve yourself of the guidance of the stars: but to know the laws of their nomandic life, your own must be fixed.

The astronomer, with his sextant revolving on a fixed pivot, looks up to the vault of the

heavens and beholds their zodiac; prescient of
what else with optic glass the Tuscan artist
viewed, at evening, from the top cf Fesole.

Above the dome of heaven, as yet unseen,
are the Lord of the worlds and His angels.
To-day, the Dawn and the Daystar: to-mor-
row, the Daystar arising in the heart.

9. Defensive architecture. The building of
the watch-tower. The beginning of security
in possession.

10. Pottery. The making of pot, cup, and
platter. The first civilized furniture; the
means of heating liquid, and serving drink and
meat with decency and economy.

11. Riding. The subduing of animals to
domestic service.

12. Weaving. The making of clothes with
swiftness, and in precision of structure, by
help of the loom.

13. Law, revealed as directly from heaven.

14. Dædalus (not Icarus, but the father try-
ing the wings). The conquest of the element
of air.

As the seventh subject of the first group in-
troduced the arts of home after those of the
savage wandering, this seventh of the second
group introduces the arts of the missionary, or
civilized and gift-bringing wanderer.

15. The Conquest of the Sea. The helms-
man, and two rowers, rowing as Venetians,
face to bow.

16. The Conquest of the Earth. Hercules
victor over Antæus. Beneficent strength of
civilization crushing the savageness of inhu-
manity.

17. Agriculture. The oxen and plow.

18. Trade. The cart and horses.

19. And now the sculpture over the door of
the tower. The Lamb of God, expresses the .
Law of Sacrifice, and door of ascent to heaven.
And then follow the fraternal arts of the Chris-
tian world.

20. Geometry. Again the angle sculpture,
introductory to the following series. We shall
see presently why this science must be the
foundation of the rest.

21. Sculpture.

22. Painting.

23. Grammar.

24. Arithmetic. The laws of number,
weight, and measures of capacity.

25. Music. The laws of number, weight (or
force), and measure, applied to sound.

26. Logic. The laws of number and measure
applied to thought.

27. The Invention of Harmony.

You see now—by taking first the great division of pre-Christian and Christian arts, marked by the door of the Tower; and then the divisions into four successive historical periods, marked by its angles—that you have a perfect plan of human civilization. The first side is of the nomad life, learning how to assert its supremacy over other wandering creatures, herbs, and beasts. Then the second side is the fixed home life, developing race and country; then the third side, the human intercourse between stranger races; then the fourth side, the harmonious arts of all who are gathered into the fold of Christ.

Now let us return to the first angle, and examine piece by piece with care.

1. Creation of Man. Scarcely disengaged from the clods of the earth, he opens his eyes to the face of Christ. Like all the rest of the sculptures, it is less the representation of a past fact than of a constant one. It is the continual state of man, 'of the earth,' yet seeing God.

Christ holds the book of His Law—the 'Law of Life'—in His left hand.

The trees of the garden above are,—central above Christ, palm (immortal life); above

Adam, oak (human life). Pear, and fig, and a
large-leaved ground fruit (what?) complete the
myth of the Food of Life.

As decorative sculpture, these trees are
especially to be noticed, with those in the two
next subjects, and the Noah's vine as differing
in treatment from Giotto's foliage, of which
perfect examples are seen in 16 and 17.
Giotto's branches are set in close sheaf-like
clusters; and every mass disposed with ex-
treme formality of radiation. The leaves of
these first on the contrary, are arranged with
careful concealment of their ornamental sys-
tem, so as to look inartificial. This is done so
studiously as to become, by excess, a little
unnatural!—Nature herself is more decorative
and formal in grouping. But the occult de-
sign is very noble, and every leaf modulated
with loving, dignified, exactly right and suffi-
cient finish; not done to show skill, nor with
mean forgetfulness of main subject, but in ten-
der completion and harmony with it.

Look at the subdivisions of the palm leaves
with your magnifying glass. The others are
less finished in this than in the next subject.
Man himself incomplete, the leaves that are
created with him, for his life, must not be so.

(Are not his fingers yet short; growing?)

2. Creation of Woman. Far, in its essential qualities, the transcendent sculpture of this subject, Ghiberti's is only a dainty elaboration and beautification of it, losing its solemnity and simplicity in a flutter of feminine grace. The older sculptor thinks of the Uses of Womanhood, and of its dangers and sins, before he thinks of its beauty; but, were the arm not lost, the quiet naturalness of this head and breast of Eve, and the bending grace of the submissive rendering of soul and body to perpetual guidance by the hand of Christ— (grasping the arm, note, for full support)— would be felt to be far beyond Ghiberti's in beauty, as in mythic truth.

The line of her body joins with that of the serpent-ivy round the tree trunk above her: a double myth—of her fall, and her support afterward by her husband'ss trength. "Thy desire shall be to thy husband." The fruit of the tree—double-set filbert, telling nevertheless the happy equality.

The leaves in this piece are finished with consummate poetical care and precision. Above Adam, laurel (a virtuous woman is a crown to her husband); the filbert for the two together; the fig, for fruitful household joy (under thy vine and fig-tree—but vine pro-

perly the masculine joy) ; and the fruit taken
by Christ for type of all naturally growing
food, in his own hunger.

Examine with lens the ribbing of these
leaves, and the insertion on their stem of the
three laurel leaves on extreme right, and
observe that in all cases the sculptor works the
molding with his own part of the design; look
how he breaks variously deeper into it, begin-
ning from the foot of Christ, and going up to
the left into full depth above the shoulder.

3. Original labor. Much poorer, and inten-
tionally so. For the myth of the creation of
humanity, the sculptor uses his best strength,
and shows supremely the grace of womanhood;
but in representing the first peasant state of
life, makes the grace of woman by no means
her conspicuous quality. She even walks
awkwardly; some feebleness in foreshortening
the foot also embarrassing the sculptor. He
knows its form perfectly—but its perspective,
not quite yet.

The trees stiff and stunted—they also need-
ing culture. Their fruit dropping at present
only into beasts' mouths.

4. Jabal. If you have looked long enough,
and carefully enough, at the three previous

sculptures, you cannot but feel that the hand
here is utterly changed. The drapery sweeps in
broader, softer, but less true folds; the hand-
ling is far more delicate; exquisitely sensitive
to gradation over broad surfaces—scarcely
using an incision of any depth but in outline;
studiously reserved in appliance of shadow, as
a thing precious and local—look at it above
the puppy's head, and under the tent. This
is assuredly painter's work, not mere sculp-
tor's. I have no doubt whatever it is by the
own hand of the shepherd-boy of Fesole. Cim-
abue had found him drawing (more probably
scratching with Etrurian point) one of his
sheep upon a stone. These, on the central
foundation-stone of his tower he engraves, look-
ing back on the fields of life: the time soon
near for him to draw the curtains of his tent.

I know no dog like this in method of draw-
ing, and in skill of giving the living form with-
out one touch of chisel for hair, or incision for
eye, except the dog barking at Poverty in the
great fresco of Assisi.

Take the lens and look at every piece of the
work from corner to corner—note especially as
a thing which would only have been enjoyed
by a painter, and which all great painters do

intensely enjoy—the fringe of the tent,* and
precise insertion of its point in the angle of
the hexagon; prepared for by the archaic mas-
onry indicated in the oblique joint above; arch-
itect and painter thinking at once, and doing
as they thought.

I gave a lecture to the Eaton boys a year or
two ago, on little more than the shepherd's dog,
which is yet more wonderful in magnified scale
of photograph. The lecture was partly pub-
lished—somewhere, but I can't refer to it.

5. Jubal. Still Giotto's, though a little less
delighted in; but with exquisite introduction of
the Gothic of his own tower. See the light
surface sculpture of a mosaic design in the hor-
izontal molding.

Note also the painter's freehand working of
the complex mouldings of the table—also
resolvedly oblong, not square; see central
flower.

6. Tubal Cain. Still Giotto's, and entirely
exquisite; finished with no less care than the
shepherd, to mark the vitality of this art to
humanity; the spade and hoe—its heraldic

* 'I think Jabal's tent is made of leather; the relaxed
intervals between the tent-pegs show a curved ragged
edge like leather near the ground" (Mr. Caird). The
edge of the opening is still more characteristic, I think.

bearing—hung on the hinged door.* For subtlety of execution, note the texture of wooden block under anvil, and of its iron hoop. The workman's face is the best sermon on the dignity of labor yet spoken by thoughtful man. Liberal Parliaments and fraternal Reformers have nothing essential to say more.

7. Noah. Andrea Pisano's again, more or less imitative of Giotto's work.

8. Astronomy. We have a new hand here altogether. The hair and drapery bad; the face expressive, but blunt in cutting; the small upper heads, necessarily little more than blocked out, on the small scale; but not suggestive of grace in completion: the minor detail worked with great mechanical precision, but little feeling; the lion's head, with leaves in its ears, is quite ugly; and by comparing the work of the small cusped arch at the bottom with Giotto's soft handling of the mouldings of his, in 5, you may forever know common

*Pointed out to me by Mr. Caird, who adds farther, "I saw a forge identical with this one at Pelago the other day—the anvil resting on a tree-stump: the same fire, bellows, and implements; the door in two parts, the upper part like a shutter, and used for the exposition of finished work as a sign of the craft; and I saw upon it the same finished work of the same shape as in the bas-relief—a spade and a hoe.

mason's work from fine Gothic. The zodiacal signs are quite hard and common in the method of bas-relief, but quaint enough in design: Capricorn, Aquarius, and Pisces, on the broad heavenly belt; Taurus upside down, Gemini, and Cancer, on the small globe.

I think the whole a restoration of the original panel, or else an inferior workman's rendering of Giotto's design, which the next piece is, with less question.

9. Building. The larger figure, I am disposed finally to think, represents civic power, as in Lorenzetti's fresco at Siena. The extreme rudeness of the minor figures may be guarantee of their originality; it is the smoothness of mass and hard edge work that make me suspect the 8th for a restoration.

10. Pottery. Very grand; with much painter's feeling, and fine moldings again. The tiled roof projecting in the shadow above, protects the first Ceramicus-home. I think the women are meant to be carrying some kind of wicker or reed-bound water-vessel. The Potter's servant explains to them the extreme advantages of the new invention. I can't make any conjecture about the author of this piece.

11. Riding. Again Andrea Pisano's, it seems to me. Compare the tossing up of the dress behind the shoulders, in 3 and 2. The head is grand, having nearly an Athenian profile; the loss of the horse's fore-leg prevents me from rightly judging of the entire action. I must leave riders to say.

12. Weaving. Andrea's again, and of extreme loveliness; the stooping face of the woman at the loom is more like a Leonardo drawing than sculpture. The action of throwing the large shuttle, and all the structure of the loom, and its threads, distinguishing rude or smooth surface, are quite wonderful. The figure on the right shows the use and grace of finely woven tissue, under and upper—that over the bosom so delicate that the line of separation from the flesh of the neck is unseen. If you hid with your hand the carved masonry at the bottom, the composition separates itself into two pieces, one disagreeably rectangular. The still more severely rectangular masonry throws out by contrast all that is curved and rounded in the loom and unites the whole composition; that is its æsthetic function; its historical one is to show that

weaving is queen's work, not peasant's: for
this is palace masonry.

13. The Giving of Law. More strictly, of
the Book of God's Law: the only one which
can ultimately be obeyed.*

The authorship of this is very embarrassing
to me. The face of the central figure is most
noble, and all the work good, but not delicate;
it is like original work of the master whose
design No. 8 might be a restoration.

14. Dœdalus. Andrea Pisano again; the
head superb, founded on Greek models,

*Mr. Caird convinced me of the real meaning of this
sculpture. I had taken it for the giving of a book, writ-
ing further of it as follows:

All books, rightly so called, are Books of Law, and all
Scripture is given by inspiration of God. (What we now
mostly call a book, the infinite reduplication and vibra-
tory echo of a lie, is not given but belched up out of vol-
canic clay by the inspiration of the devil.) On the Book-
giver's right hand the students in cell, restrained by the
lifted right hand.

"Silent, you—till you know;" then, perhaps, you also.
On the left, the men of the world, kneeling, receive
the gift.

Recommendable seal, this, for Mr. Mudie!

Mr. Caird says: "The book is written law, which is
given by Justice to the inferiors, that they may know
the laws regulating their relations to their superiors—
who are also under the hand of law. The vassal is pro-
tected by the accessibility of formularized law. The
superior is restrained by the right hand of power."

feathers of wings wrought with extreme care;
but with no precision of arrangement or feel-
ing. How far intentional in awkwardness, I
cannot say; but note the good mechanism of
the whole plan, with strong standing board for
the feet.

15. Navigation. An intensely puzzling one;
coarse (perhaps unfinished) in work, and done
by a man who could not row; the plaited bands
used for rowlocks being pulled the wrong way.
Right, had the rowers been rowing English-
wise; but the water at the boat's head shows
its motion forward, the way the oarsmen look.
I cannot make out the action of the figure at
the stern; it ought to be steering with the
stern oar.

The water seems quite unfinished. Meant,
I suppose, for surface and section of sea, with
slimy rock at the bottom; but all stupid and in-
efficient.

16. Hercules and Antæus. The Earth
power, half hidden by the earth, its hair and
hand becoming roots, the strength of its life
passing through the ground into the oak tree.
With Cercyon, but first named (Plato, Laws,
Book VII., 796), Antæus is the master of con-

test without use; and is generally the power
of pure selfishness and its various inflation to
insolence and degradation to cowardice;—find-
ing its strength only in fall back to its Earth,
—he is the master, in a word, of all such kind
of persons as have been writing lately about
the "interests of England." He is, therefore,
the Power invoked by Dante to place Virgil
and him in the lowest circle of Hell;—"Alcides
whilom felt,—that grapple, straitened sore,"
etc. The Antaeus in the sculpture is very
grand; but the authorship puzzles me, as of
the next piece, by the same hand. I believe
both Giotto's design.

17. Plowing. The sword in its Christian
form. Magnificent: the grandest expression
of the power of man over the earth and its
strongest creatures that I remember in early
sculpture,—(or, for that matter in late). It is
the subduing of the bull which the sculptor
thinks most of; the plow, though large, is of
wood, and the handle slight. But the pawing
and bellowing laborer he has bound to it!—
here is victory.

18. The Chariot. The horse also subdued to
draught—Achilles' chariot in its first, and to

be its last, simplicity. The face has probably
been grand—the figure is so still. Andrea's,
I think, by the flying drapery.

19. The Lamb, with the symbol of Resurrec-
tion. Over the door: "I am the door;—by
me, if any man enter in," etc. Put to the
right of the tower, you see, fearlessly, for the
convenience of staircase ascent; all external
symmetry being subject with the great build-
ers to interior use; and then, out of the rightly
ordained infraction of formal law, comes per-
fect beauty; and when, as here, the Spirit of
Heaven is working with the designer, his
thoughts are suggested in truer order, by the
concession to use. After this sculpture comes
the Christian arts,—those which necessarily
imply the conviction of immortality. Astron-
omy without Christianity only reaches as far
as—"Thou hast made him a little lower than
the angels—and put all things under His feet:"
—Christianity says beyond this,—"Know ye
not that we shall judge angels (as also the lower
creatures shall judge us!)" The series of
sculptures now beginning, show the arts which
can only be accomplished through belief in
Christ.

20. Geometry. Not "mathematics:" they have been implied long ago in astronomy and architecture; but the due Measuring of the Earth and all that is on it. Actually done only by Christian faith—first inspiration of the great Earth-measurers. Your Prince Henry of Spain, your Columbus, your Captain Cook (whose tomb, with the bright artistic invention and religious tenderness which are so peculiarly the gifts of the nineteenth century, we have just provided a fence for, an old cannon open-mouthed, straight up toward Heaven—your modern method of symbolizing the only appeal to Heaven of which the nineteenth century has left itself capable—"The voice of thy Brother's blood crieth to me"—your outworn cannon, now silently agape, but sonorous in the ears of angels with that appeal)—first inspiration, I say, of these; constant inspiration of all who set true landmarks and hold to them, knowing their measure; the devil interfering, I observe, lately in his own way, with the Geometry of Yorkshire, where the landed proprietors,*

*I mean no accusation against any class; probably the one fielded statesman is more eager for his little gain of fifty yards of grass than the square for his bite and sup out of the gypsy's part of the roadside. But it is notable enough to the passing traveler, to find himself shut into a narrow road between high stone dykes which he can neither see over nor climb over (I always deliber-

when the neglected walls by the roadside
tumble down, benevolently repair the same,
with better stonework, outside always of the
fallen heaps;—which, the wall being thus built
on what was the public road, absorb them-
selves, with help of moss and time, into the
heaving swells of the rocky field—and behold,
gain of a couple of feet—along so much of the
road as needs repairing operations.

This, then, is the first of the Christian
sciences:—division of land rightly, and the
general law of measuring between wisely-held
compass points. The type of mensuration,
circle in square, on his desk, I use for my first
exercise in the laws ot Fesole.

21. Sculpture. The first piece of the closing
series on the north side of the Campanile, of
which some general points must be first noted,
before any special examination.

The two initial ones, Sculpture and Paint-
ing, are by tradition the only ones attributed
to Giotto's own hand. The fifth, Song, is
known, and recognizable in its magnificence,

———

ately pitch them down myself, wherever I need a gap),
instead of on a broad road between low gray walls with
all the moor beyond—and the power of leaping over
when he chooses, in innocent trespass for herb, or
view, or splinter of gray rock.

to be by Luca della Robbia. The remaining
four are all of Luca's school,—later work there-
fore, all these five, than any we have been
hitherto examining, entirely different in man-
ner, and with late flower-work beneath them
instead of our hitherto severe Gothic arches.
And it becomes of course instantly a vital
question—Did Giotto die leaving the series
incomplete, only its subjects chosen, and are
these two bas-reliefs of Sculpture and Painting
among his last works? or was the series ever
completed, and these later bas-reliefs substi-
tuted for the earlier ones, under Luca's influ-
ence, by way of conducting the whole to a
grander close, and making their order more
representative of Florentine art in its fullness
of power?

I must repeat, once more, and with greater
insistence respecting Scripture than Painting,
that I do not in the least set myself up for a
critic of authenticity,—but only of absolute
goodness. My readers may trust me to tell
them what is well done or ill; but by whom, is
quite a separate question, needing for any
certainty, in this school of much associated
masters and pupils, extremest attention to
minute particulars not at all bearing on my
objects in teaching.

Of this closing group of sculptures, then, all I can tell you is that the fifth is a quite magnificent piece of work, and recognizably, to my extreme conviction, Luca della Robbia's; that the last, Harmonia, is also fine work; that those attributed to Giotto are fine in a different way,—and the other three in reality the poorest pieces in the series, though done with much more advanced sculptural dexterity.

But I am chiefly puzzled by the two attributed to Giotto, because they are much coarser than those which seem to me so plainly his on the west side, and slightly different in workmanship—with much that is common to both, however, in the casting of drapery and mode of introduction of details. The difference may be accounted for partly by haste or failing power, partly by the artist's less deep feeling of the importance of these merely symbolic figures, as compared with those of the Fathers of the Arts; but it is very notable and embarrassing notwithstanding, complicated as it is with extreme resemblance in other particulars.

You cannot compare the subjects on the tower itself; but of my series of photographs take 6 and 21, and put them side by side.

I need not dwell on the conditions of resemblance, which are instantly visible; but

the difference in the treatment of the heads is incomprehensible. That of the Tubal Cain is exquisitely finished, and with a painter's touch; every lock of the hair laid with studied flow, as in the most beautiful drawing. In the "Sculpture," it is struck out with ordinary tricks of rapid sculptor trade, entirely unfinished, and with offensively frank use of the drill hole to give picturesque rustication to the beard.

Next, put 22 and 5 back to back. You see again the resemblance in the earnestness of both figures, in the unbroken arcs of their backs, in the breaking of the octagon molding by the pointed angles; and here, even also in the general conception of the heads. But again, in the one of Painting, the hair is struck with more vulgar indenting and drilling, and the Gothic of the picture frame is less precise in touch and later in style. Observe, however, —and this may perhaps give us some definite hint for clearing the question,—a picture-frame would be less precise in making and later in style, properly, than cusped arches to be put under the feet of the inventor of all musical sound by breath, of man. And if you will now compare finally the eager tilting of the workman's seat in 22 and 6, and the working of the wood in the painter's low table for his pots of

color, and his three-legged stool, with that of
Tubal Cain's anvil block; and the way in which
the lines of the forge and upper triptych are
in each composition used to set off the round-
ing of the head, I believe you will have little
hesitation in accepting my own view of the
matter.—namely, that the three pieces of the
Fathers of the Arts were wrought with Giotto's
extremest care for the most precious stones of
his tower; that also, being a sculptor and
painter, he did the other two, but with quite
definite and willful resolve that they should
be, as mere symbols of his own two trades,
wholly inferior to the other subjects of the
patriarchs; that he made the Sculpture pictur-
esque and bold as you see it is, and showed all
a sculptor's tricks in the work of it; and a
sculptor's Greek subject, Bacchus, for the
model of it; that he wrought the Painting, as
the higher art, with more care, still keeping it
subordinate to the primal subjects, but showed,
for a lesson to all the generations of painters
for evermore,—this one lesson, like his circle
of pure line, containing all others,—"Your soul
and body must be all in every touch."

I can't resist the expression of a little piece
of personal exultation, in noticing that he holds
his pencil as I do myself: no writing master,

and no effort (at one time very steady for many months), having ever cured me of that way of holding both pen and pencil between my fore and second finger; the third and fourth resting the backs of them on my paper.

As I finally arrange these notes for press, I am further confirmed in my opinion by discovering little finishings in the two later pieces which I was not before aware of. I beg the masters of High Art, and sublime generalization, to take a good magnifying glass to the "Sculpture" and look at the way Giotto has cut the compasses, the edges of the chisels, and the keyhole of the lock of the tool-box.

For the rest, nothing could be more probable, in the confused and perpetually false mass of Florentine tradition, than the preservation of the memory of Giotto's carving his own two trades, and the forgetfulness, or quite as likely ignorance, of the part he took with Andrea Pisano in the initial sculptures.

I now take up the series of subjects at the point where we broke off, to trace their chain of philosophy to its close.

To Geometry, which gives to every man his possession of house and land, succeed 21. Sculpture, and 22, Painting, the adornments

of permanent habitation. And then, the great
arts of education in a Christian home. First—

23. Grammar, or more properly Literature
altogether, of which we have seen the ancient
power in the Spanish Chapel series; then,

24. Arithmetic, central here as also in the
Spanish Chapel, for the same reasons; here,
more impatiently asserting, with both hands,
that two, on the right, you observe—and two
on the left—do indeed and forever make Four.
Keep your accounts, you, with your book of
double entry, on that principle; and you will
be safe in this world and the next, in your
steward's office. But by no means so, if you
ever admit the usurer's Gospel of Arithmetic,
that two and two make Five.

You see by the rich hem of his robe that the
asserter of this economical first principle is a
man well to do in the world.

25. Logic. The art of Demonstration.
Vulgarest of the whole series; far too expres-
sive of the mode in which argument is con-
ducted by those who are not masters of its
reins.

26. Song. The essential power of music in
animal life. Orpheus, the symbol of it all,
the inventor properly of Music, the Law of
Kindness, as Dædalus of Music, the Law of

Construction. Hence the "Orphic life" is one
of ideal mercy (vegetarian),—Plato, Laws,—
and he is named first after Dædalus, and in
balance to him as head of the school of har-
monists, in Book III. Look for the two sing-
ing birds clapping their wings in the tree
above him: then the five mystic beasts,—clos-
est to his feet the irredeemable boar; then lion
and bear, tiger, unicorn, and fiery dragon
closest to his head, the flames of its mouth
mingling with his breath as he sings. The
audient eagle, alas! has lost the beak, and is
only recognizable by his proud holding of him-
self; the duck, sleepily delighted after muddy
dinner, close to his shoulder, is a true con-
quest. Hoopoe, or indefinite bird of crested
race, behind; of the other three no clear cer-
tainty. The leafage throughout such as only
Luca could do, and the whole consummate in
skill and understanding.

27. Harmony. Music of Song, in the full
power of it, meaning perfect education in
all art of the Muses and of civilized life: the
mystery of its concord is taken for the symbol
of that of a perfect state; one day, doubtless,
of the perfect world. So prophesies the last
corner stone of the Shepherd's Tower.